IMAGES
of America

GROTON

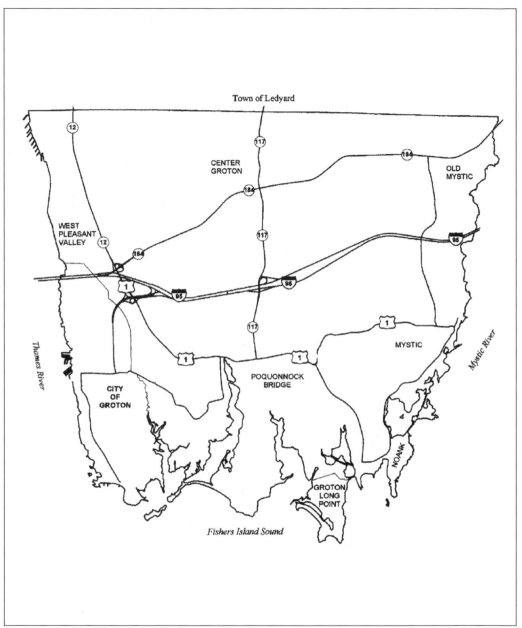

This map shows the town of Groton.

IMAGES

of America

GROTON

Carol W. Kimball, James L. Streeter,
and Marilyn J. Comrie

ARCADIA
PUBLISHING

Published by Arcadia Publishing
Charleston SC, Chicago IL, Portsmouth NH, San Francisco CA

Printed in the United States of America

Library of Congress Catalog Card Number: 2003115211

For all general information contact Arcadia Publishing at:
Telephone 843-853-2070
Fax 843-853-0044
E-mail sales@arcadiapublishing.com
For customer service and orders:
Toll-Free 1-888-313-2665

Visit us on the Internet at www.arcadiapublishing.com

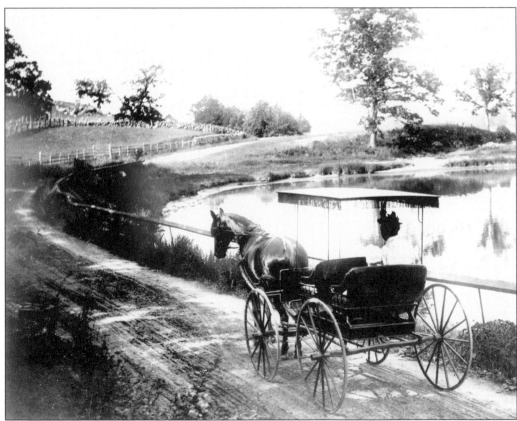

Mrs. Edward Newbury rides along River Road in Mystic with her daughter Adah in this c. 1890 photograph. (Carol W. Kimball.)

CONTENTS

ACKNOWLEDGMENTS

The authors wish to thank the following people and organizations for their assistance in making this book possible: Barbara Tarbox (Groton town clerk), Mystic Seaport, the Indian and Colonial Research Center, William N. Peterson, Joan Cohn, the Ferguson family, the Submarine Force Library and Museum, Kenneth Trail, Cassie Crane Pine, Almira F. Linton, the Groton Town Police Department, the Electric Boat Corporation, Carl Bryson, Thomas Norton, Ed Costa, Tom Migliaccio, Priscilla Pratt, Sav Giordano, Paul Stubing, Ramona Pugsley Comrie, John Scott, Colleen Temple, Arthur Greenleaf, Wes Greenleaf, Ann C. Brown, Barbara Parfitt, Kim Kohrs, Mabel Exley Brown, Thomas L. Hagerty, the Groton Public Library, Wally Trolan, Robert Bankel, Claude Fowler at Gigante Grinders, the U.S. Navy, Lou Martel, Jack Vibber, Bill Sanford, the City of Groton Parks and Recreation Department, and Dorothy Ann Peckham Morrison.

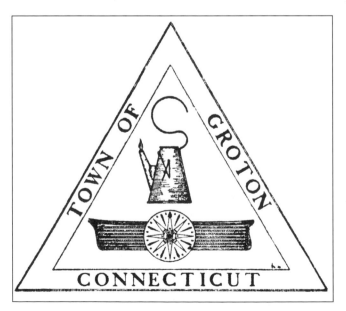

The first seal of the town of Groton was designed by Theodore F. Norton of Mystic and adopted in 1935 in honor of the Connecticut tercentenary. The elements typify three maritime activities in the town's history. The boat hull along the bottom represents the clipper ship *Andrew Jackson,* built in Mystic. The circular drawing on the model is from a card compass used in the Noank fishing smack *Fair Lady.* The article drawn in the inner triangle is a forecastle lamp from a blacksmith shop in Groton that did repairs for the local whaling fleet. (Town of Groton.)

INTRODUCTION

Groton is known as the submarine capital of the world. The town earned that distinction during the 20th century when, early in that century, the General Dynamics Electric Boat Division built a shipyard on the Thames River. Around the same time, the U.S. Navy established a submarine base upriver from the shipyard.

For decades, Electric Boat (EB) was the town's and the region's largest employer. In the early 1950s, EB built the world's first nuclear-powered submarine, the USS *Nautilus* (SSN 571). When the *Nautilus* was decommissioned, it came back home to Groton and is now the centerpiece of the Submarine Force Library and Museum, adjacent to the submarine base. The EB shipyard was instrumental in helping America win World War II. In 1943, EB turned out a submarine nearly every two weeks, a feat that helped the town earn its title of submarine capital. EB and the submarine base were also key factors in helping America win the cold war. Groton's proximity to Long Island Sound and the fact that its eastern and western boundaries are the Mystic and Thames Rivers made shipbuilding a key industry from very early in the town's history.

The heyday of shipbuilding along the Mystic River was the 19th century, when clipper ships and packets were a mainstay of the town's industry. Shipyards in Mystic built some important 19th-century vessels, including the clipper ship *Andrew Jackson,* which made a record-setting voyage between New York and San Francisco, and the Civil War's USS *Galena,* the first ocean-going ironclad of the Union navy.

In the 20th century, much of the town's shipbuilding shifted to the Thames River and the construction of submarines. But some shipyards in Mystic were still active, many of them servicing the rumrunning boats along the East Coast that smuggled illegal alcohol ashore during Prohibition, in the 1920s and early 1930s. Southern New England waters, including Groton's shoreline, became known as Rum Row.

Groton was incorporated as a town in 1705, when it separated from New London, but its history dates back to the early 1600s. A major battle of the Pequot War, the 1637 Pequot Massacre, took place on Pequot Hill in Mystic when a party led by Maj. John Mason attacked one of the tribe's forts, setting it afire and killing hundreds of Indian men, women, and children.

Groton, like many New England towns, is made up of a series of villages. The best known is Mystic, nestled along the Mystic River, the town's eastern boundary. Established in 1654, Mystic is now the state's most popular tourist destination. Other villages include Noank, at the mouth of the Mystic River and known for its seaside beauty; Old Mystic, at the head of

the Mystic River; Center Groton; Poquonnock Bridge; and Eastern Point and Pleasant Valley, along the shores of the Thames River.

Also within the town is the City of Groton, an incorporated borough that is the industrial heart of Groton and is home to Electric Boat, Pfizer, and Groton Utilities. Incorporated as a borough in 1903, the City of Groton was the first part of town to have electricity, sewers, and other amenities as much of the rest of the town remained agricultural and rural until well into the 20th century.

Groton is also home to Connecticut's only intact Revolutionary War fort—Fort Griswold Battlefield State Park. High on a hill overlooking the Thames River and the city of New London, the fort was the setting for the September 6, 1781, battle of Groton Heights, where British forces, aided by the traitor Benedict Arnold, attacked the fort and burned the city of New London across the harbor.

In the 1830s, residents erected a monument to the 185 men who defended the colonies' freedom at Fort Griswold. The 134-foot-tall stone structure, older than both the Bunker Hill and Washington Monuments, has become a symbol of Groton and is part of the history lessons of every schoolchild in town.

Groton's rich history includes the earliest struggles to settle New England and a battle that was part of America's fight for independence. The town has quintessential New England villages and the shoreline beauty of the Bluff Point Coastal Preserve, Avery Point, and the waters of eastern Long Island Sound.

The town has played a role in providing vessels and soldiers for all of America's major conflicts, right down to the present. Ships from the submarine base participated in Operation Iraqi Freedom and continue to patrol the world's oceans to help protect our nation.

As Groton prepares to mark its 300th anniversary in 2005, this book pays tribute to the town's history with photographs ranging from the 1880s to 1960. Happy birthday, Groton.

One

MARITIME GROTON

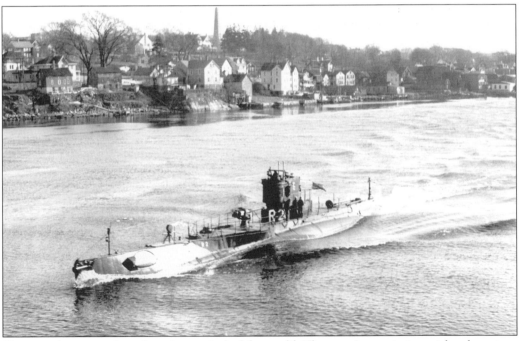

Groton is known as the submarine capital of the world. The town's association with submarines began in 1868, when a navy yard was created on the banks of the Thames River. During World War I, the navy yard became a base for the military's brand-new submarine fleet. In 1911, Electric Boat came to town and, in 1925, built its first submarine. In this *c.* 1920 photograph, submarine R-2 travels upriver to the submarine base with the Groton Monument and the houses of Groton Bank in the background. (Carol W. Kimball.)

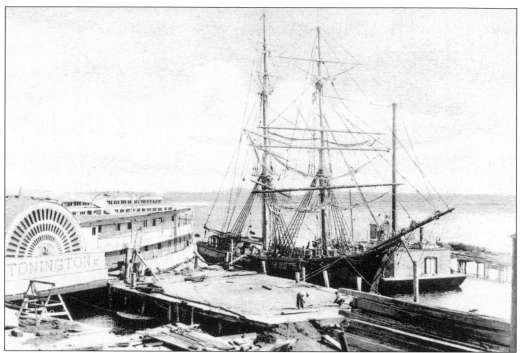

The Palmer Shipyard, in Noank, built and repaired many vessels. On the left is the steamer *Stonington*, and on the right is an old vessel in for repairs. (Jim Streeter.)

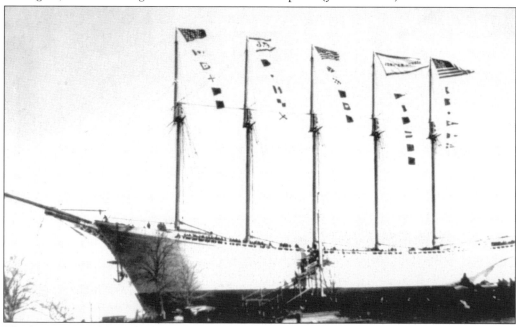

The largest vessel launched on the Mystic River was the five-masted wooden schooner *Jennie R. Dubois*. It was 249 feet long and weighed 2,227 tons. It was launched at Old Field in West Mystic on February 11, 1902, by the Holmes Shipbuilding Company. The coal schooner was used in coastal trade. It sank in 1903 after it collided with a German tramp schooner off Block Island. (Carol W. Kimball.)

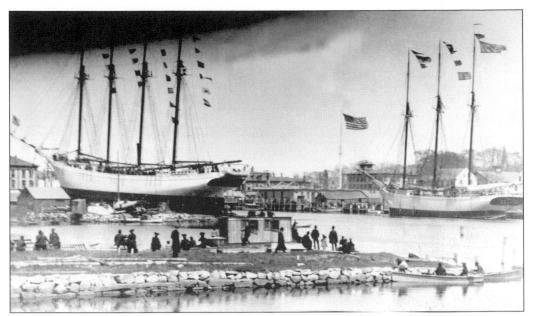

The four-masted schooner *Marie Gilbert*, on the left, was built by the Gilbert Transportation Company, just south of the Mystic highway bridge. Launched in 1906, the 435-ton schooner was named for Capt. Mark Gilbert's wife. On the right is the schooner *Fortuna*, also owned by the Gilberts, who urged their stockholders to put their faith in sailing vessels because steam would never last. (Carol W. Kimball.)

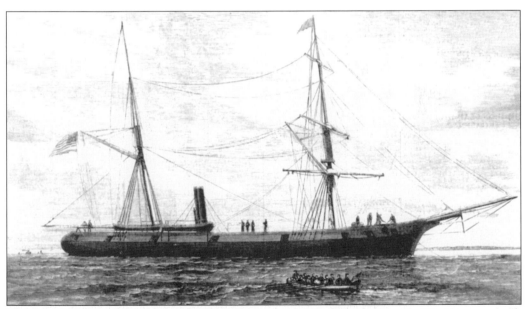

The Civil War ironclad USS *Galena*, shown in a picture from *Harper's Weekly*, was built by Maxson and Fish in West Mystic. The first ocean-going ironclad of the Union navy was launched on February 14, 1862. At the launching, many thought the weight of the iron plating would cause the ship to sink, but "she floats like a duck," the local newspaper reported. After a defeat at Drewry's Bluff, Virginia, the *Galena* was converted to a wooden corvette and served the navy until 1890. (Carol W. Kimball.)

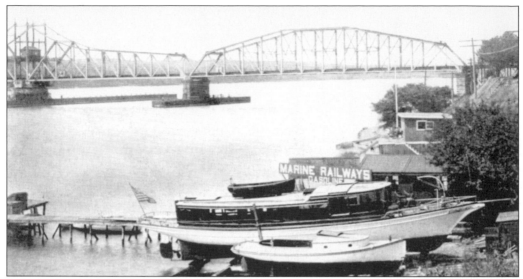

Vessels of all sizes were built along the banks of the Thames River, from small launches to huge steel freighters and submarines. This photograph shows the Marine Railway, for vessels not longer than 50 feet. The railroad bridge across the Thames is in the background. (Jim Streeter.)

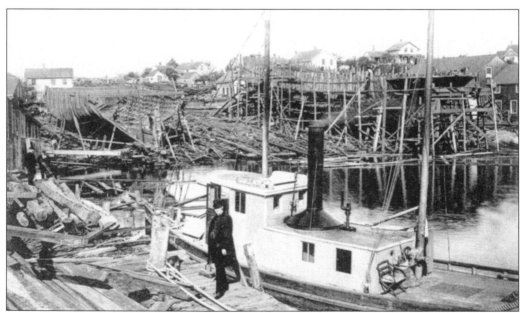

Shipbuilding is a rich part of Groton's heritage. In 1859, brothers Robert and John Palmer formed the R & J Palmer Shipyard in the village of Noank and built Groton's first marine railway for the repair of large vessels. The firm grew to be one of the largest wooden shipbuilding plants on the East Coast, employing more than 600 people. It built a variety of vessels, from fishing smacks to the palatial sound steamers *Rhode Island*, *Connecticut*, and *Nashua*. (Jim Streeter.)

Noank, at the mouth of the Mystic River, was always a fishing village known for building smacks and sloops. This scene shows shore activity in the early 20th century. In the background on the right is the summer hotel the Ashbey House. (Jim Streeter.)

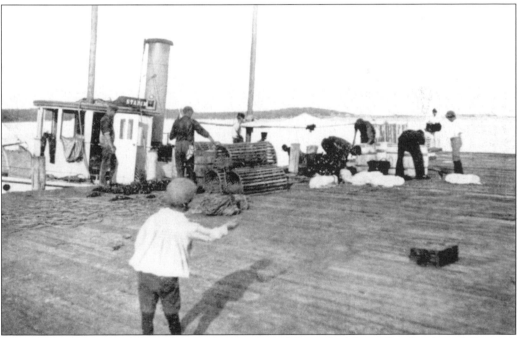

At its height, Noank's fishing fleet had 100 vessels fishing the Nantucket shoals and George's Bank and sailing to southern ports. The village was also a lobstering center. In 1883, 90 men were lobstering, setting out 3,000 pots. The lobsters were packed and shipped to New York. (Jim Streeter.)

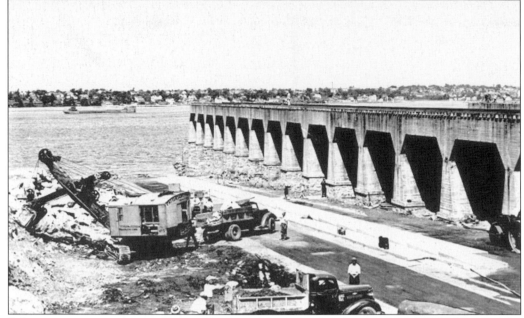

Submarine construction at Electric Boat in Groton helped America win World War II. The expansion for the war effort began when the South Yard opened in 1941. The Victory Yard was blasted out of the old Groton Iron Works and began production in 1942. (Claude Fowler at Gigante Grinders.)

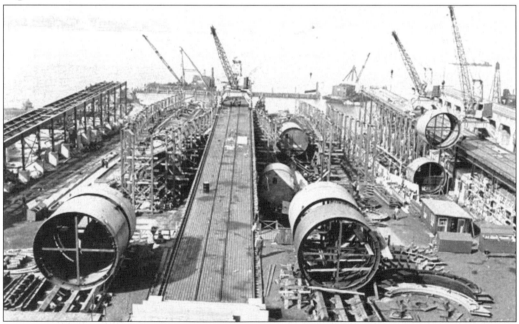

Here, submarine hulls are under construction at the Electric Boat Victory Yard during World War II. From 21 ways, EB delivered 74 fleet-type submarines during the war, more than any other yard in the country. Groton submarines account for 39 percent of all Japanese shipping destroyed during the war. This stunning effort contributed to Groton earning the title "submarine capital of the world." (Claude Fowler at Gigante Grinders.)

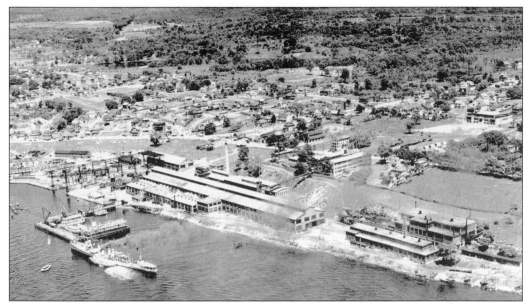

Seen is an aerial view of Electric Boat c. 1937. Electric Boat decided to build diesel engines and opened a plant on the Thames River in 1911. The company, then known as Nelseco, built its first submarine, which was for Peru, in 1925. In 1929, the company name was changed to Electric Boat, and in 1933, it launched its first submarine built for the United States—the *Cuttlefish*. Its shining moment came in 1955, when the Electric Boat–built USS *Nautilus* got "under way on nuclear power." The shipyard is still a major employer in the region. (Jim Streeter.)

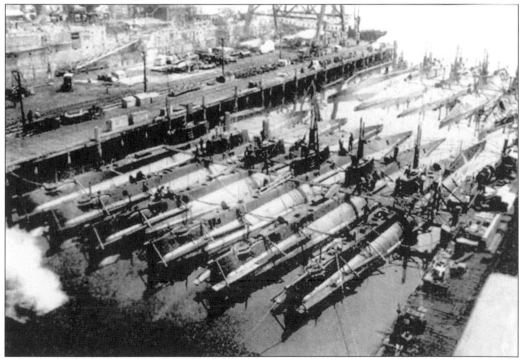

Submarine hulls are lined up under construction in the early years of the Victory Yard at Electric Boat. (Electric Boat Corporation.)

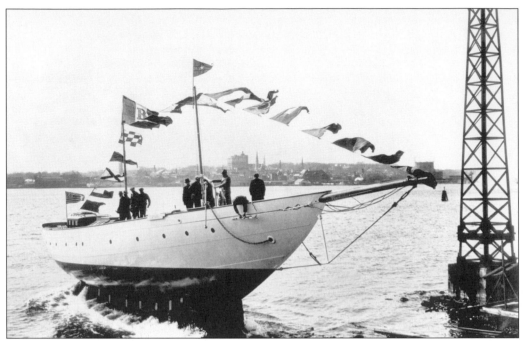

In the lean times before submarine production, Electric Boat took odd jobs and any marine work available. Here, the company launches a yacht into the Thames River. The New London shoreline is in the background. (Jim Streeter.)

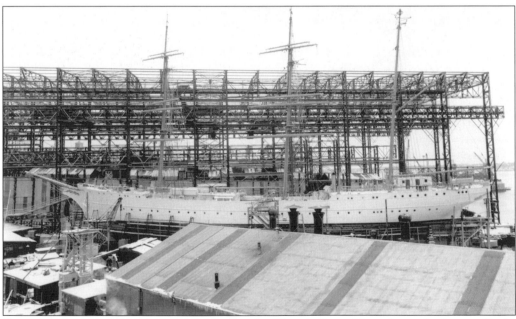

One of the most notable ships refurbished at the Electric Boat shipyard was the barque *Eagle*, now the training vessel for the U.S. Coast Guard Academy in New London. The *Eagle*, which also serves as a floating ambassador for the United States and has led all of the nation's tall ship parades in New York Harbor, was taken as a war prize from the Germans after World War II. (Jim Streeter.)

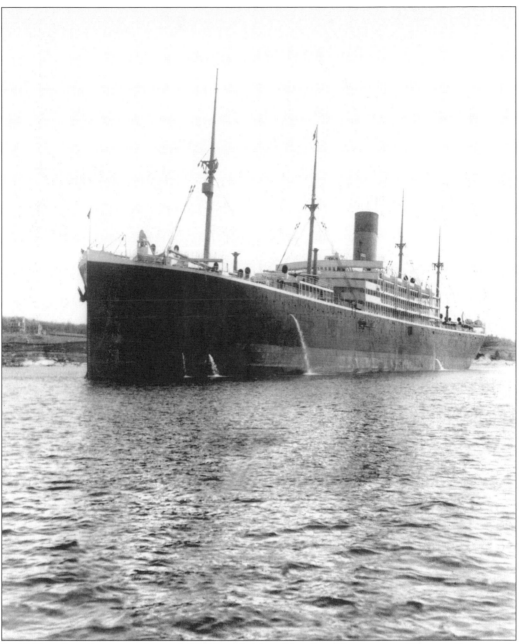

In 1900, railroad magnate James J. Hill bought the old railroad ferry site on Thames Street with plans to build giant steel freighters to carry wheat from the West to the Orient. Two vessels were built; the steamer *Minnesota*, shown here, was launched on April 16, 1903. A sister ship, the *Dakota*, was launched a year later. When completed, they sailed from Seattle to Japan but were not profitable, as there was no return cargo from Japan. The *Minnesota* served as a troop transport during World War I. (Carol W. Kimball.)

Seen is the *Dakota* under construction at the shipyard in Groton. The *Minnesota* and *Dakota* were the largest steel freighters in the world at the time of their launching. The 21,000-ton vessels were 622 feet long. They were equipped to carry cargo and 500 passengers. The *Dakota*, launched in 1904, sank off the coast of Japan in 1907. (Carol W. Kimball.)

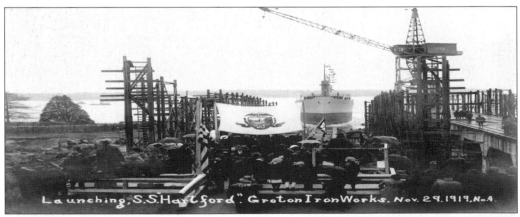

Charles W. Morse of the United States Steamship Company bought a 30-acre estate at Eastern Point in November 1916 to build steel merchant vessels for World War I. The first vessel, the *Tolland*, was launched just days before the armistice. The shipyard launched nine vessels, all too late for the war effort. Here, the SS *Hartford* is launched in 1919. The site was Electric Boat's Victory Yard during World War II and is now the site of Pfizer's Groton facility. (Carol W. Kimball.)

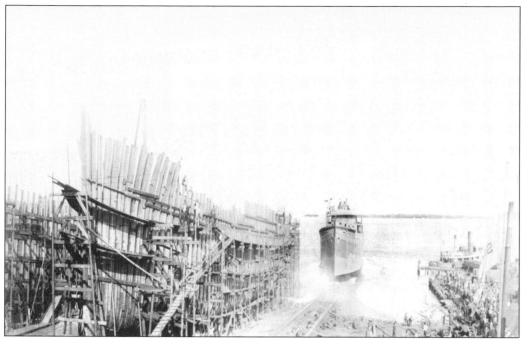

Charles W. Morse, who owned Groton Iron Works, also bought the old Palmer Shipyard during World War I and constructed several wooden cargo vessels for the war effort. (Jim Streeter.)

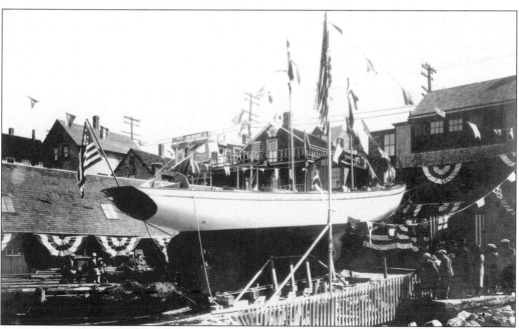

Capt. Charles P. Ferguson and his father built vessels behind 137 Thames Street in Groton. The firm was one of the last private boatbuilders in the area. Here, the auxiliary yacht *Lou* is launched for J. L. Hubbard of Norwich on April 21, 1928. The 63-foot-long yacht was powered by a 65-horsepower Lathrop engine, built by the Lathrop Engine Company in Mystic. (Ferguson family collection.)

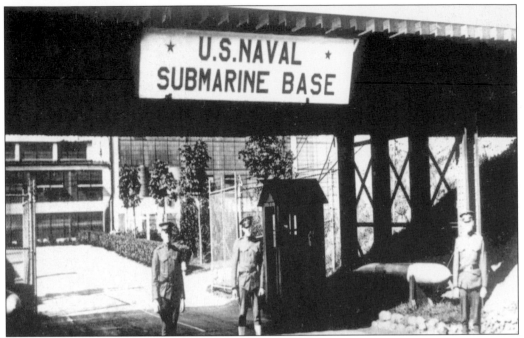

This 1919 photograph shows the first entrance to the submarine base in Groton. Although the base's official name is Naval Submarine Base New London, the facility is now and has always been along the eastern shores of the Thames River in Groton. (U.S. Navy.)

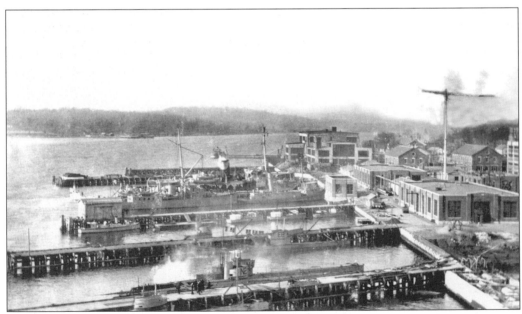

Seen is the submarine base waterfront in 1919. The 1868 navy yard was converted to a submarine base prior to World War I to service the newly created fleet of underwater vessels. The U.S. Navy and the town have had a long and enduring relationship. In 1978, the navy honored the town by commissioning the Los Angeles class submarine USS *Groton*. (U.S. Navy.)

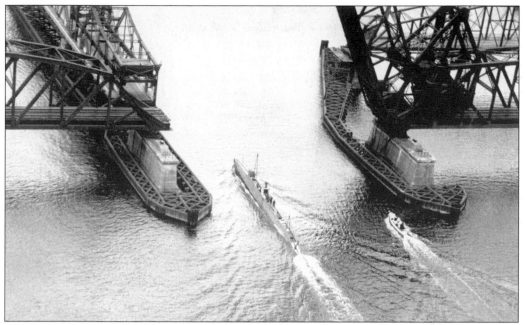

In June 1931, the polar submarine *Nautilus* sails down the Thames River and out to sea. The submarine was part of the Wilkins-Ellsworth Arctic Submarine Expedition in 1931, which attempted to reach the North Pole under the ice. A future submarine, also named *Nautilus* and driven by nuclear power, would achieve that feat more than 25 years later. In this photograph, the submarine is passing through the railroad bridge and the first vehicular highway bridge on the Thames. The New York and New Haven Railroad replaced its first railroad bridge, built in 1889, with a new bridge in 1919 to accommodate heavier freight loads. The state of Connecticut purchased the old railroad bridge and converted it for motor vehicle traffic. It opened in 1919. The first span of the Gold Star Memorial Bridge opened in February 1943. (Jim Streeter.)

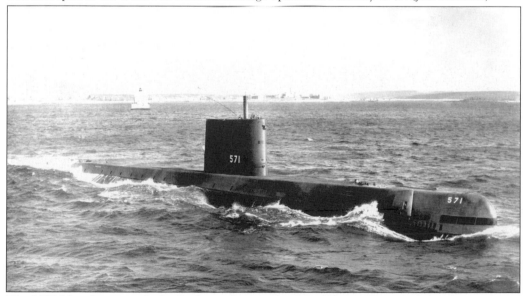

The USS *Nautilus* passes Ledge Light at the mouth of the Thames River as it heads out to sea. (Jim Streeter.)

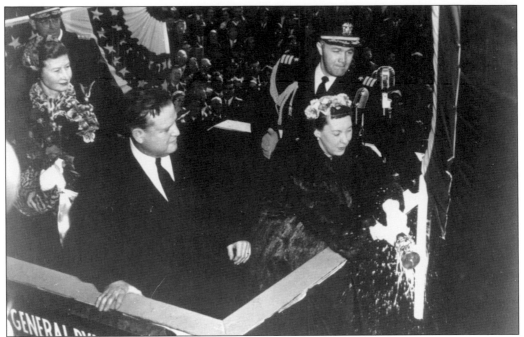

First Lady Mamie Eisenhower breaks a bottle of champagne over the bow of the USS *Nautilus*, America's first nuclear-powered submarine, built at Electric Boat and launched in January 1954. A year later, when the *Nautilus* radioed the now famous phrase "under way on nuclear power," the era of nuclear-powered submarines was born. Today, Groton is the permanent home of the *Nautilus*. The submarine is the centerpiece of the Submarine Force Library and Museum at the entrance to the submarine base. (Submarine Force Library and Museum.)

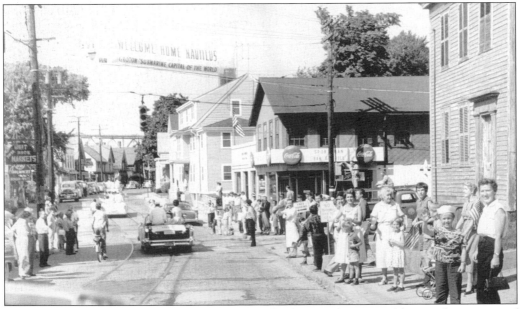

The town celebrates the return of the USS *Nautilus* from its first tour of duty in the summer of 1955. People line both sides of Thames Street in the City of Groton as a parade of dignitaries passes by. (Jim Streeter.)

Two

PEOPLE AND PLACES

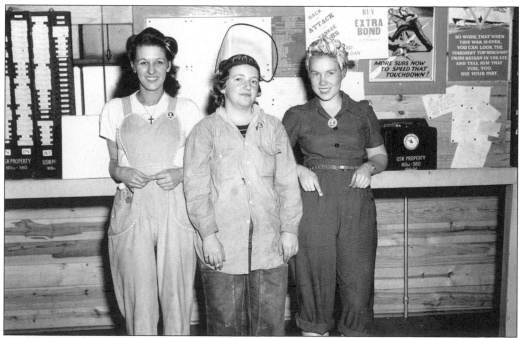

Rosie the Riveter was alive and well at Electric Boat in Groton as women did their part to build the submarines that helped the Allies win World War II. Pictured here are three women at EB during the war. They wrapped their pin curls in kerchiefs and went to work to win the U.S. Navy "E" for efficiency. (Electric Boat Corporation.)

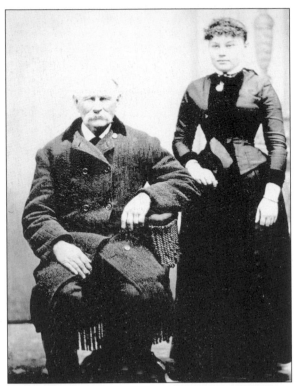

Capt. James Monroe Buddington is shown with and his second wife, Julia S. Woodward. Buddington, who was born at Groton in 1817, is best known for his 1855 whaling expedition to the Arctic, where he discovered the *Resolute*, an English vessel from Sir John Franklin's expedition, abandoned and stuck in the ice. He freed it, sailed it back to New London, restored it, and presented it to Queen Victoria as a gesture of U.S. friendship. When the British retired the ship, Victoria had a desk made from its timbers, which was given to Pres. Rutherford B. Hayes. (Kenneth Trail.)

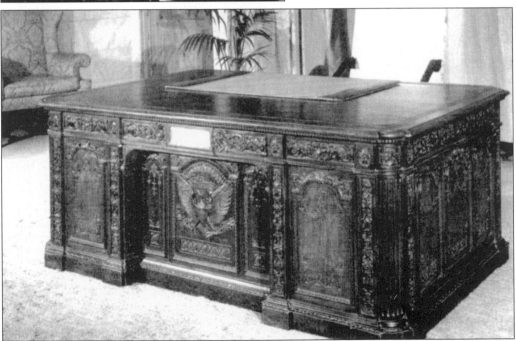

The *Resolute* desk has been in the White House since 1881. Pres. John F. Kennedy moved the desk to the Oval Office when he became president in 1961, and it has been used as the official desk by every president since. A replica is on display at the John F. Kennedy Library in Boston. (Carol W. Kimball.)

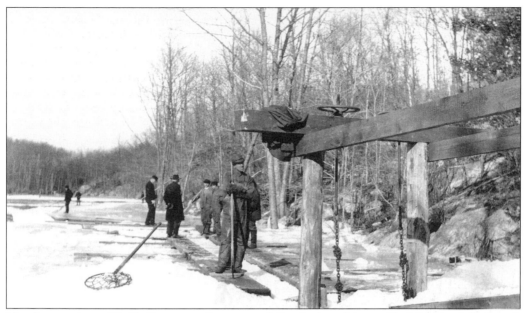

Men harvest ice at Trail's Corner on Poquonnock Road where Marcus Trail dammed the brook to make a pond. He built an 80-foot icehouse with a capacity of 1,000 tons to fill neighborhood iceboxes in the days before electric refrigeration. In 1907, when this photograph was taken, he had 17 men cutting cakes of ice to store in sawdust for summer use. The property now belongs to General Dynamics. (Cassie Crane Pine.)

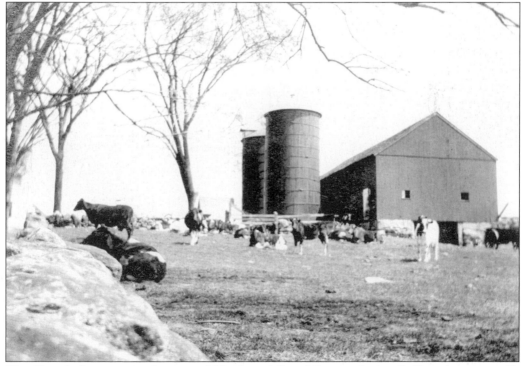

The Crouch farm was in the area of North and Broad Streets. Irving E. Crouch was a milk dealer in 1917. (Jim Streeter.)

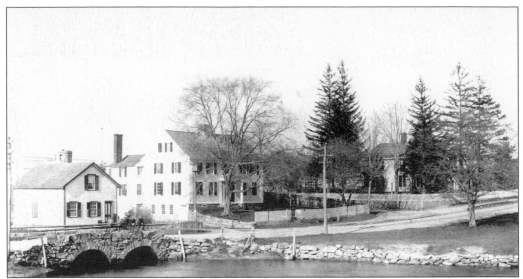

Rev. Fenimore Cooper took this photograph from South Road, looking north across Route 1 in Poquonnock Bridge between 1900 and 1904. The house on the left, the Renaldi house, now stands at Midway Oval. The center house, home of Denison Smith c. 1800 and later the Mill House, disappeared after 1930. The house on the right, built by Franklin Gallup, was later owned by Marcus L. Trail. Between these houses is the lane leading to the old wooden schoolhouse. (Almira F. Linton.)

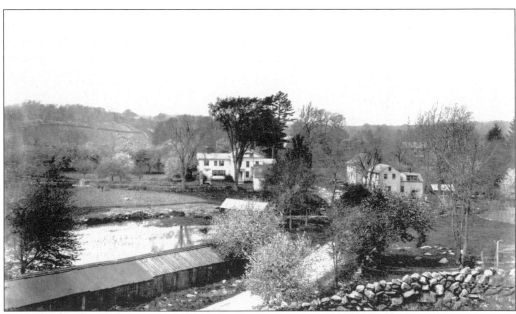

The town of Groton has always been composed of villages and political subdivisions that had lives of their own. Burnett's Corners was a thriving village in the early years of the 20th century, with its own schoolhouse, the Pequot Hotel, a blacksmith shop, and a line walk (the long building on the left) where Leander Barber made clotheslines. Today, it is a quiet neighborhood on Packer Road listed on the National Register of Historic Places. (Indian and Colonial Research Center.)

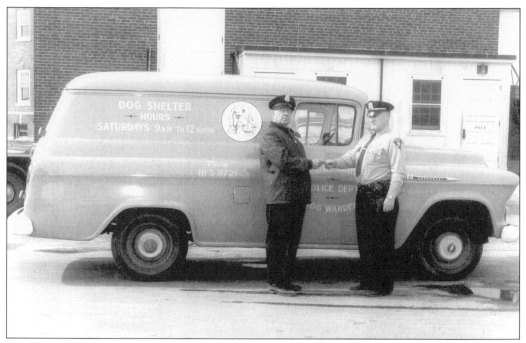

Police Chief John Scroggins, right, talks with John Phillips, the dog warden, in this 1940s photograph outside the police station, which for years was in the basement of town hall on Fort Hill Road. (Groton Town Police Department.)

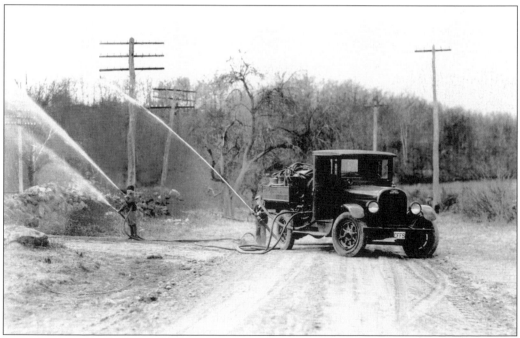

A trucker demonstrates the equipment on Groton's forest fire truck. In the 1930s, a fire tower stood on Fort Hill and was used for observation of forest fires. (Jim Streeter.)

Hard-driving Capt. John E. Williams (1816–1901) poses in front of the home he built on Gravel Street in Mystic. The house still stands. In the Mystic-built clipper *Andrew Jackson*, Williams made a record-setting voyage between New York and San Francisco. Williams was immortalized as "Kicking Jack Williams" in the sea chantey "Blow the Man Down." (Carol W. Kimball.)

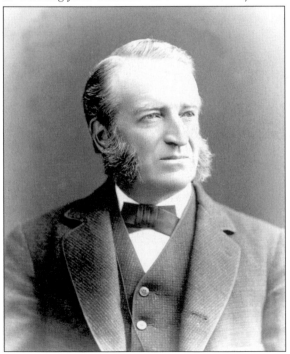

J. Warren Holmes was one of Mystic's most famous and prominent sea captains. In his 63-year career, he rounded Cape Horn 84 times and never lost a man or a ship. He regularly visited San Francisco, where this photograph was taken. In retirement, he lived in Mystic in a house on High Street. He died in 1912 at the age of 88. (Carol W. Kimball.)

Mystic's peace meetings were held at Great Hill on River Road from 1866 until after the Spanish-American War. Organized by the Universal Peace Union, the annual meetings were held in August with nationally famous speakers. Those participating considered world peace, women's suffrage, racial issues, and other reform movements. It was a great social time attended by thousands. This 1890s photograph shows the Mystic River and Elm Grove Cemetery in the background. The land was later purchased by Mary Jobe Akeley, who opened a camp for girls on the site. (Indian and Colonial Research Center.)

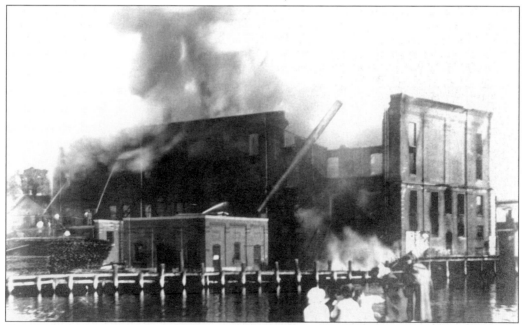

One of the spectacular fires in Mystic occurred on June 25, 1915, when the Gilbert Block, on West Main Street next to the drawbridge, burned. The four-story structure held the offices of the bankrupt Gilbert Transportation Company, a theater, and the Noyes dry goods store. In 1924, the brick facade became the Main Block. Today, the structure is part of the Steamboat Wharf complex. (Carol W. Kimball.)

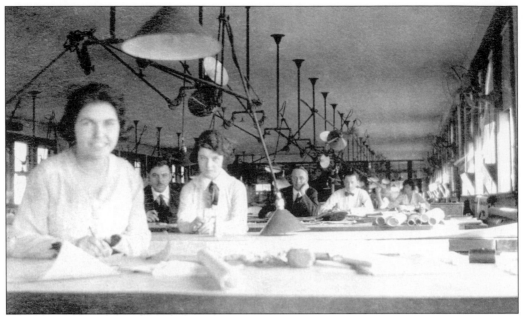

Workers sit at the drafting tables at the New London Ship and Engine Company on the Eastern Shipbuilding site. The company was a predecessor to Electric Boat. During its early years, it made diesel engines for submarines and submarine parts. Beginning in World War I, it employed women. (Jim Streeter.)

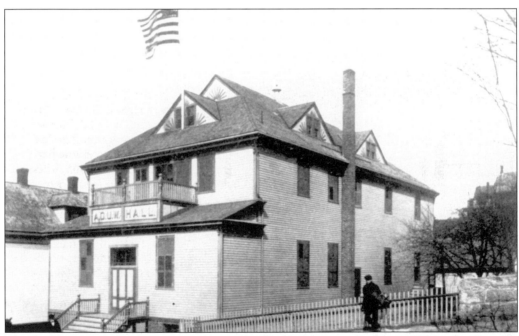

This building on School Street in Groton has had many uses. Built in 1895 as the Ancient Order United Workmen's Hall, a meeting place for the fraternal organization, it later served as an Elks Club hall and as the Groton Playhouse. In 1915, it was the Delphi Theater and showed daily movies. Today, it is the Submarine Veterans Club. (Jim Streeter.)

Four generations of the Bailey family from Groton pose in this photograph, taken in September 1887. From left to right are Silas P. Bailey (83), Moses O. Bailey (55), Judson S. Bailey (1½), and Oliver D. Bailey (27). (Carol W. Kimball.)

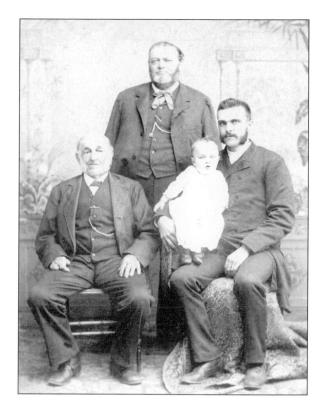

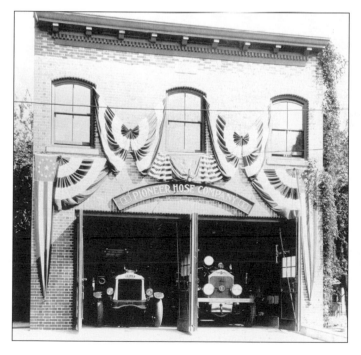

In 1917, a new firehouse was built on Pleasant Street for the borough's Pioneer Hose Company. The fire department remained at this site until 1965, when it moved to a new fire headquarters on Broad Street. This photograph, taken in the 1930s, shows two fire trucks, including a Kelly ladder truck, inside the facility. The building was subsequently sold and was once used as the headquarters for the Groton Ambulance Association. It is now owned and used as offices and a meeting hall by the Machinists Union Local. (Jim Streeter.)

This photograph, taken c. 1888, shows the E. J. Chapman farmhouse, which was on South Road in Poquonnock. The house was removed during the expansion of Trumbull Airport. (Kenneth Trail.)

Robert Burrows, a carpenter, built this Victorian house for himself on Pleasant Street in the City of Groton. (Jim Streeter.)

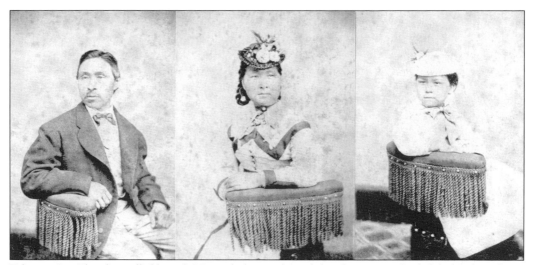

Eskimos Joe Ebierbing (left), wife Hannah (center), and daughter Puny (right) helped explorer Charles Francis Hall on the *Polaris* expedition to reach the North Pole. The three came to Groton with Capt. Sidney Budington, and they lived in the Pleasant Valley section of Groton. Joe later returned north, but Puny and Hannah are buried in Starr Cemetery. (Indian and Colonial Research Center.)

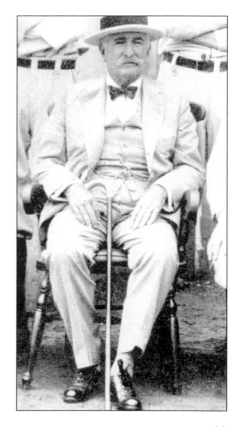

Morton F. Plant was one of the town's great benefactors. He built Groton's new town hall in 1908 and assisted many area churches, built the Griswold Hotel, and helped develop what is today the town's municipal golf course. Plant was heir to his father's fortune, made from steamboats and railroads in Florida. H. B. Plant was one of the early developers of Florida. Morton Plant came to Groton at the turn of the century to build his summer estate, Branford House, at Avery Point, now the southeastern campus of the University of Connecticut. (Jim Streeter.)

THE NEW ENGLAND

ALMANAC

AND FARMERS' FRIEND.

FOR THE YEAR OF OUR LORD CHRIST

1903:

BEING THE SEVENTH AFTER BISSEXTILE OR LEAP YEAR,

—AND THE—

One Hundred and Twenty-Seventh of American Independence.

Calculated for the Meridian of New London, Latitude 41° 21′ N., Longitude 72° 05′ W.

BY DAVID A. DABOLL,

CENTER GROTON, CONN.

Containing besides the Astronomical Calculations, a Variety of Matter both Useful and Entertaining.

THE HUSBANDMAN.

" Time is a wise, consistent husbandman;
For first he sows the fruitfullness of smiles
Upon our faces, youths' soft dewy tears
And early sunshine. Then he brings his plow
And drives his wand'ring furrows ruthlessly,
Sows cares and disciplines; and last of all,
When life's experience is golden ripe,
He swings betimes his gentle, painless scythe
Amid the bearded harvest bent with snow."

The *New England Almanac,* a precursor to the *Old Farmer's Almanac,* was published by the Daboll family, who lived in Center Groton. (Jim Streeter.)

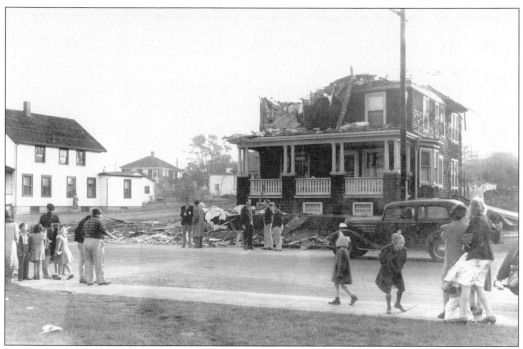

On October 19, 1944, a U.S. Navy fighter plane on night maneuvers struck this house on Chicago Avenue. The pilot and a small child in the house suffered minor injuries. The pilot and the daughter of the owner of the house subsequently married. (Thomas Norton.)

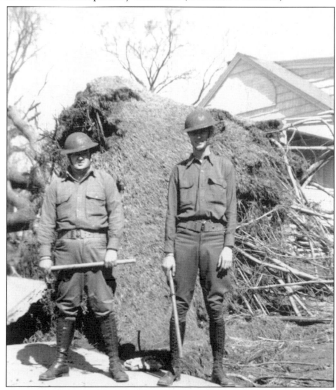

Martial law was declared throughout southern New England following the devastating hurricane of September 21, 1938. Here, "Fats" Aitkens (left) and "Slim" Bailey patrol a portion of Eastern Point after the storm. (Tom Migliaccio.)

This 1931 photograph shows the borough of Groton utility building. It was built in 1908 to house the Groton Electric Lighting Company, now called Groton Utilities. Located on the river side of Thames Street, the building also housed the borough police department and government offices and, for a few years, the borough fire department. The utility building was sold to private owners after the City of Groton municipal building was built in 1966. The building subsequently housed a World War II submarine museum and gift shop and several restaurants. (Jim Streeter.)

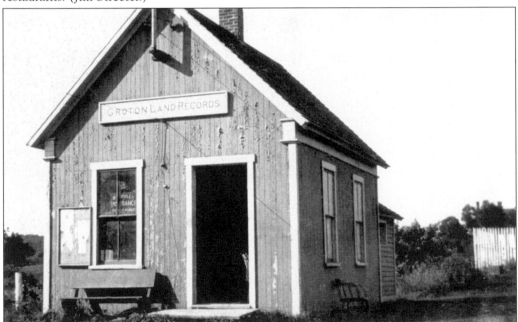

In earlier times, it was customary for town clerks to keep town records in their homes. When Nelson Morgan was elected Groton town clerk in 1895, he built this two-room wooden office for the records. It first stood on Depot Road and was then moved to Fort Hill Road on Route 1, where it stood on the site of Johnson's Hardware. It was used until Morton Plant gave Groton a new town hall in 1908. (Jim Streeter.)

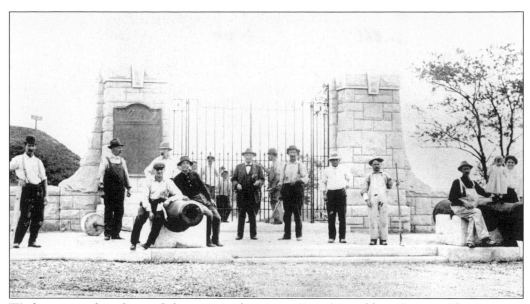

Workmen stand in front of the memorial gates at Fort Griswold in Groton. The gate was dedicated in 1911. Bronze plaques on the left post list the names of the defenders of the September 6, 1781, battle, when British troops commanded by the traitor Benedict Arnold attacked the fort. (Jim Streeter.)

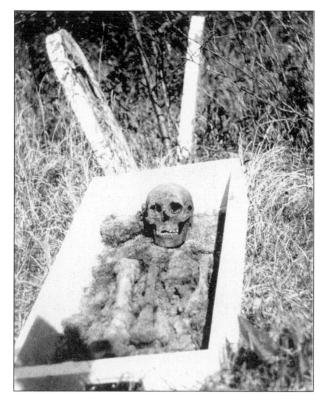

Samuel Avery was a prominent citizen in early Groton. He was the youngest son of James Avery, and J.D. Rockefeller was a lineal descendant of Avery. Samuel Avery died on May 1, 1723, and was buried in Ledyard. In 1924, the Rockefellers, with the cooperation of the Avery Memorial Association, paid to have him disinterred. He was placed in a new coffin, pictured here, and buried next to his wife in Avery Morgan Cemetery in Groton. (Jim Streeter.)

Caleb Haley is shown here in his New York office at the Fulton Fish Market. Born in Center Groton in 1838, Haley hated farming and set out for New York, where he made his fortune at the Fulton market. In 1868, he purchased the Henry Smith farm near Noank, making it into a model farm where he spent his vacations. Today, the Haley farm is part of the town's green space. (Priscilla Pratt.)

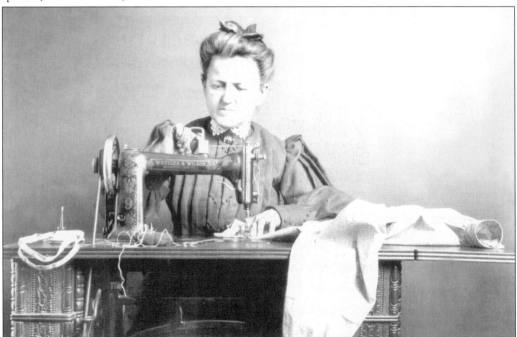

Julia Beebe Coates, wife of a prominent Mystic physician, shows her domestic side as she sits at her sewing machine. Coates was an ardent photographer whose photographs of c. 1900 Mystic are now part of the archives of the Indian and Colonial Research Center in Old Mystic. (Indian and Colonial Research Center.)

Three

LANDMARKS

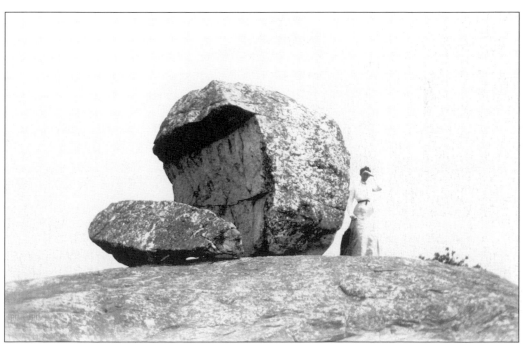

A woman stands at Jemina's Rock on Haley farm in this *c.* 1890s photograph. The prominent outcropping was named for Jemina Wilkinson, an early evangelist who is said to have preached there. (Carol W. Kimball.)

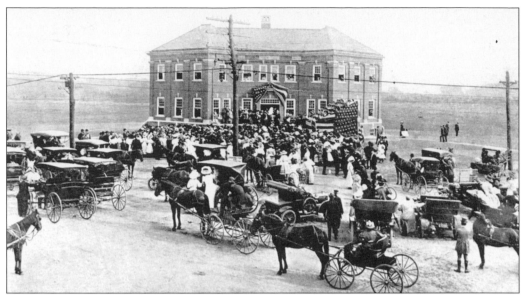

When the need for a building for town meetings became apparent, philanthropist Morton F. Plant came to the rescue, presenting the town with an impressive brick state-of-the-art $25,000 town hall built on the plains of Poquonnock. A large crowd gathered when the building was dedicated on September 17, 1908. With various additions and alterations, it is in use today. In appreciation, the townspeople gave Plant a silver loving cup, which he is receiving in the photograph. (Carol W. Kimball.)

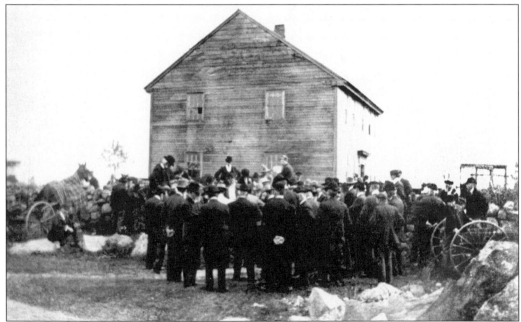

The town house stood on Fort Hill and was originally the meetinghouse of the Second Baptist Church of Groton. When the congregation moved to Mystic, the building was sold to the town and used as a municipal building until the present town hall was built in 1908. This photograph, taken c. 1904, before women's suffrage, shows only men gathered for the town meeting. (Robert Bankel.)

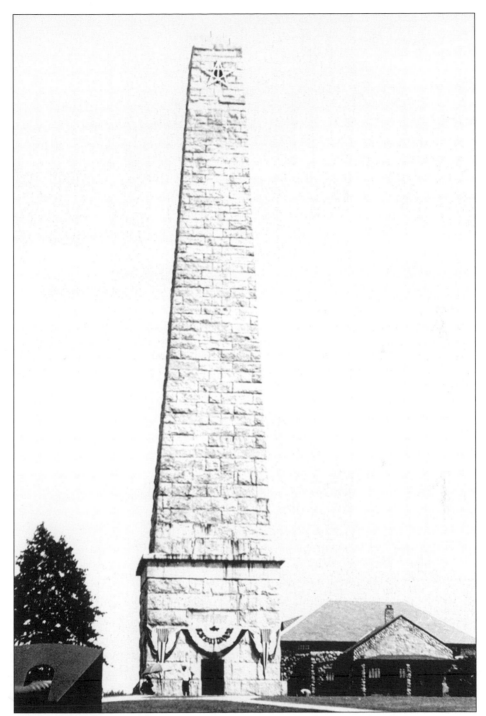

The Groton Monument commemorates the September 6, 1781, British attack on Groton and New London commanded by the traitor Benedict Arnold. The 185 defenders of the fort were overwhelmed by the superior British force. A commemorative monument was completed in 1830. In honor of the centennial of the battle, the height of the monument was increased to 134 feet. (Jim Streeter.)

The Mother Bailey House, at Thames and Broad Streets in the City of Groton, was the home of Anna Warner Bailey, one of the first women to approach the fort following the Battle of Groton Heights in September 1781. Bailey became nationally famous during the War of 1812 by donating her petticoat for wadding for the fort. The house is a private residence today. The local chapter of the Daughters of the American Revolution is named for Bailey. (Carol W. Kimball.)

This house in Center Groton was once home to the famous Groton mathematician Nathan Daboll, whose family published the *New England Almanac*. Daboll also ran a navigation school in a wing of the house where many Groton sea captains were trained in navigation and nautical astronomy. The house still stands on Candlewood Road. (Jim Streeter.)

The old Avery homestead, known as the Hive of the Averys, was a landmark in Poquonnock for more than two centuries. Built by Edward Stallion before 1670, he gave it to his daughter as a wedding gift when she married James Avery Jr. in 1670. The house was home to generations of Averys until a spark from a passing locomotive set the house on fire in 1894. A memorial was erected on the site in 1900. (Carol W. Kimball.)

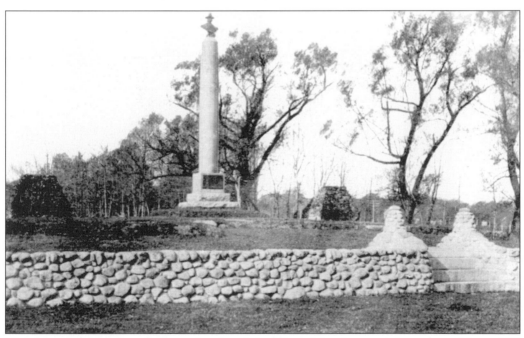

The Avery Memorial was built on the site of the Hive of the Averys at the corner of Long Hill and Poquonnock Roads after the house burned in a fire on July 20, 1894. In a wave of nostalgia, the Avery descendants formed the Avery Memorial Association and erected this stone shaft on the site in 1900. (Carol W. Kimball.)

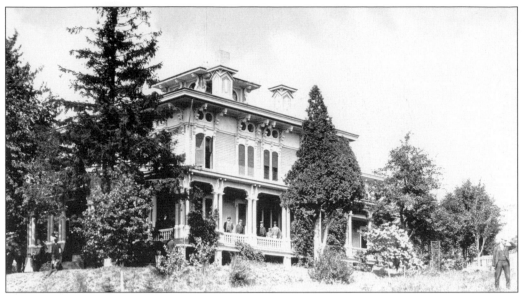

After the Civil War, Col. Robert Stafford, a Southerner, came to Groton and built an Italianate mansion on Starr Hill. He called the estate Fairview because of its commanding view of the Thames River. After Stafford's death, the Odd Fellows of Connecticut purchased the property and, in 1892, opened it as a retirement home for elderly and indigent Odd Fellows members. They enlarged the facility in 1925. Today, it operates as the Fairview Odd Fellows Home of Connecticut but is open to anyone needing health care. (Jim Streeter.)

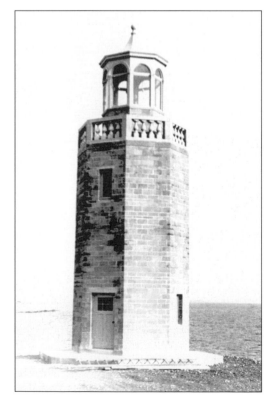

The Avery Point Lighthouse is on the University of Connecticut's Avery Point campus and was built by the U.S. Coast Guard when it used the site as its East Coast training station. Constructed in 1943, it was the last lighthouse built in the state of Connecticut. It was reportedly built as a memorial to all lighthouse keepers and other lighthouses. This photograph was taken in 1945. (Jim Streeter.)

The Indian Memorial was built in 1935 under the leadership of Eva Butler as part of the observance of Connecticut's tercentennial. The structure, which stood at the top of Fort Hill just north of the walled Burrows Cemetery, was built from timbers taken from ancient Groton houses. It was torn down and removed in 1978 and was replaced by a memorial boulder with a bronze tablet. (Carol W. Kimball.)

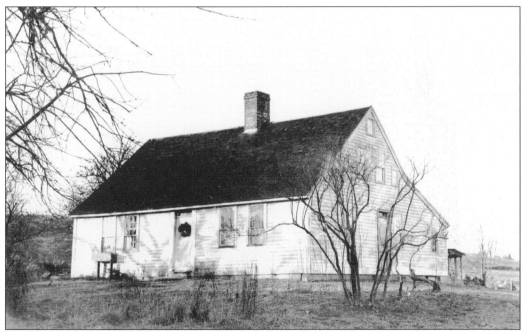

One of Groton's oldest houses was built by Edward Stallion c. 1684. Stallion was a mariner and coastal trader once fined for sailing his vessel from New London to Norwich on the Sabbath. The house still stands off Pleasant Valley Road near Pleasant Valley School. (Jim Streeter.)

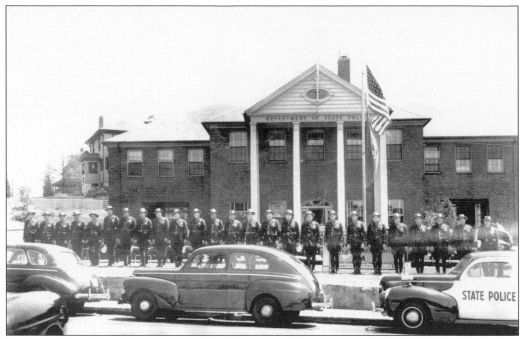

The state police barracks was on Thames Street for many years. In this 1940s photograph, officers stand at attention outside the building. In the early 1970s, when Interstate 395 opened, the barracks was moved to Troop E in Montville to be closer to that highway. (Jim Streeter.)

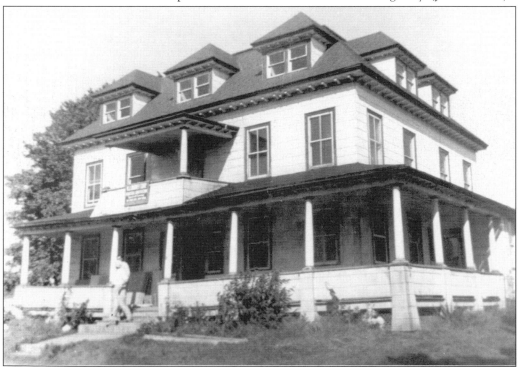

The first state police barracks in Groton was on Eastern Point Road where Pfizer now has its research facilities. (Jim Streeter.)

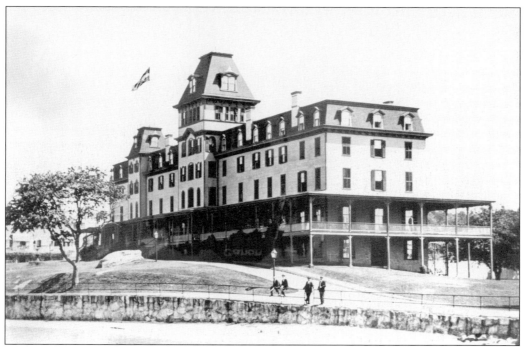

The Fort Griswold House, a famous summer hotel at Eastern Point, was replaced by Morton Plant in 1904 with a grander, more elegant hotel called the Griswold Hotel. (Jim Streeter.)

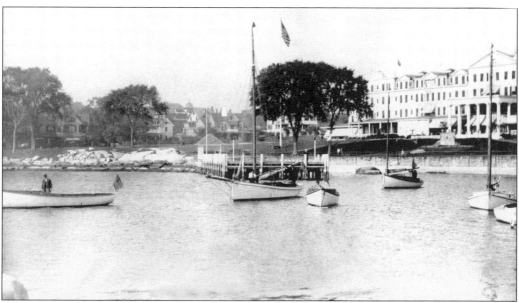

Morton F. Plant had the Griswold Hotel built to dress up the neighborhood near his summer estate, Branford House, at Avery Point. The hotel opened in June 1906 and quickly became the most elegant and fashionable hotel in southern New England. The hotel was very popular for conventions and was especially popular during the annual Yale-Harvard regatta held each June on the Thames River. The hotel was razed in 1969, and the land is now part of the Shennecossett Municipal Golf Course. (Jim Streeter.)

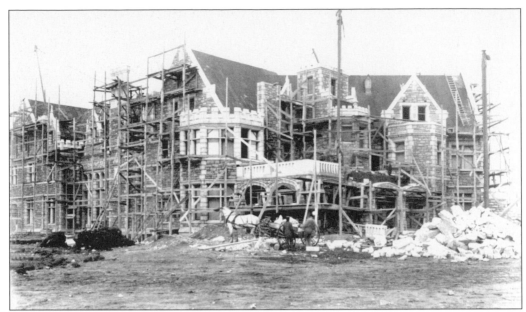

Branford House, Morton Plant's summer mansion at Avery Point, is shown under construction. Plant, heir to the Plant steamship and railroad lines, moved into the home in 1904. The grand estate, at the tip of the Thames River, is now part of the Avery Point campus of the University of Connecticut. (Jim Streeter.)

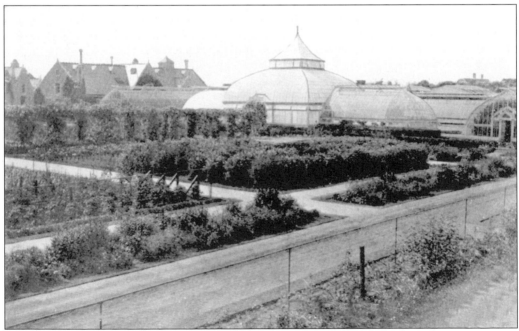

Morton Plant had gardens and magnificent greenhouses on the grounds of Branford House. The greenhouses furnished flowers for Branford House and grew prize chrysanthemums for flower shows. The gardens furnished produce for the table and for the Griswold Hotel. (Jim Streeter.)

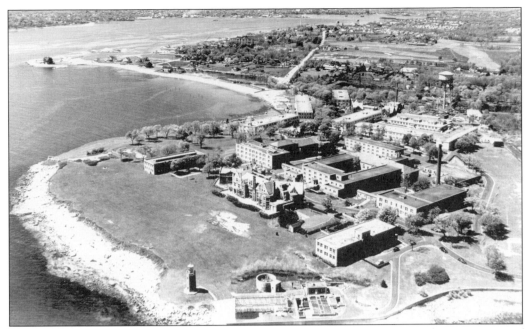

The U.S. Coast Guard built its East Coast training facilities on the former Avery Point estate of Morton F. Plant. Many thousands of recruits attended various schools at the facility from 1942 to 1967. The University of Connecticut now has its southeastern branch on the property. This aerial photograph was taken in the 1950s. (Jim Streeter.)

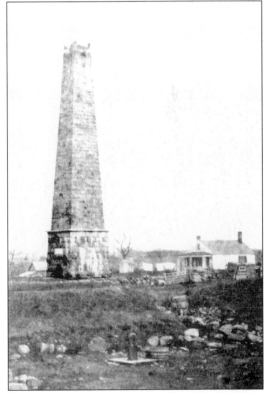

The original Groton monument was completed in 1830, financed by a lottery, to commemorate the 1781 Battle of Groton Heights. This photograph shows the monument before the top was added in 1881. At the time of the battle's centennial, the monument's height was increased to 134 feet. The stone obelisk predates the Bunker Hill and the Washington Monuments. The building on the right was the keeper's house. (Jim Streeter.)

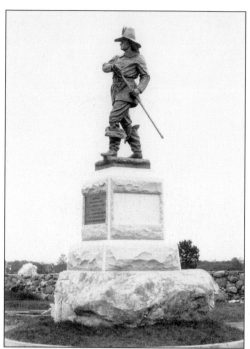

A statue of Maj. John Mason was erected by the state in 1889 in Mystic on the site of the 1637 Pequot Massacre. The controversial statue stood on Pequot Hill for 106 years. It was taken down by the state in 1995 at the request of the Mashantucket Pequot tribe, who said they consider the site of the massacre sacred ground. The statue now stands on the green in Windsor, one of the four towns in the state where Mason is considered a founding father. (Carol W. Kimball.)

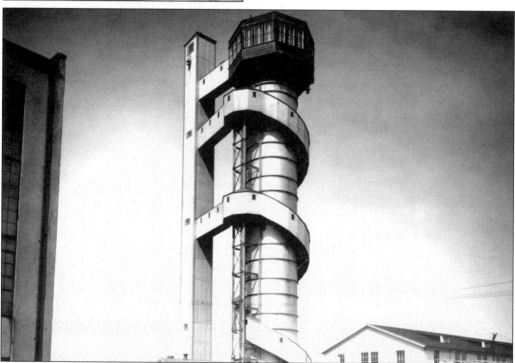

The escape training tower was long a landmark at the submarine base. The 120-foot-high steel tower was erected in 1930 after a number of submarine disasters in the 1920s led to the introduction of an escape device known as the Momsen lung. All submariners had to qualify ascending to the surface under pressure. The tower was demolished in 1991. (Submarine Force Library and Museum.)

The Morgan Point Lighthouse, in Noank, was built in 1831 to mark the mouth of the channel of the Mystic River. It was taken out of service in 1922 in favor of an automatic beacon and, with many additions, is now a private residence. (Carol W. Kimball.)

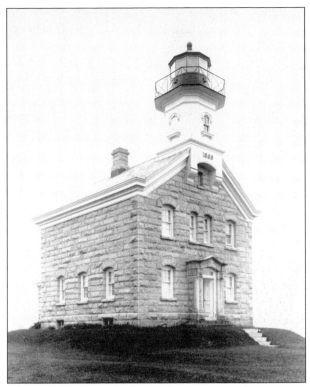

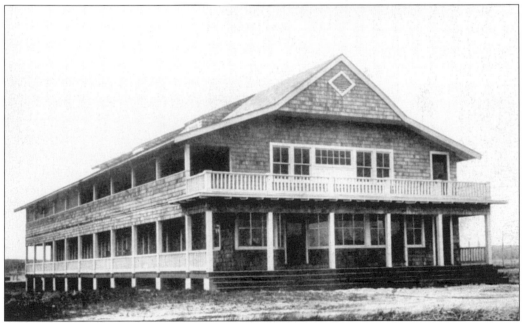

The casino at Groton Long Point was the center of social functions for the shoreline summer community. An early brochure advertised the clubhouse with its broad porches where "you could have an evening chat with your neighbors and enjoy the sea breezes." Groton Long Point was developed by James J. Smith of New London in the first decades of the 20th century. (Jim Streeter.)

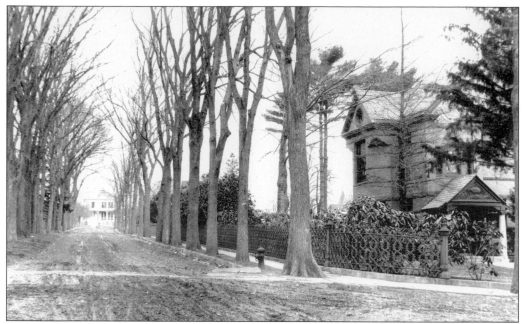

Elm Street in Mystic got its name from the magnificent elm trees that lined the street, as this 1906 photograph shows. The Mystic and Noank Library, one the village's most architecturally interesting buildings, is on the right. All of the elms, along with hundreds of other trees in town, were destroyed in the 1938 hurricane. (Indian and Colonial Research Center.)

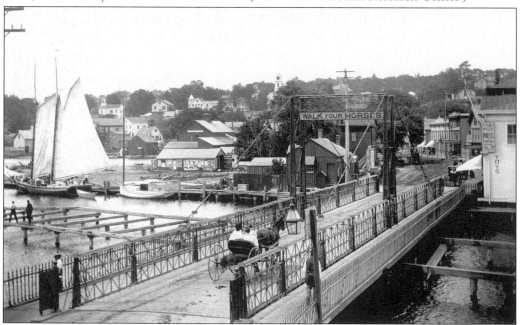

The iron bridge over the Mystic River was built in 1868, reflecting the rapid maritime growth of the village. The span swung open to allow vessels to pass to the Greenman and Mallory shipyards upriver. The river was busy with sailing vessels and steamers. The bridge bore a "Walk Your Horses" sign to avoid too much vibration on the ironwork, as this 1890 photograph shows. (Paul Stubing.)

Four

SCHOOLS

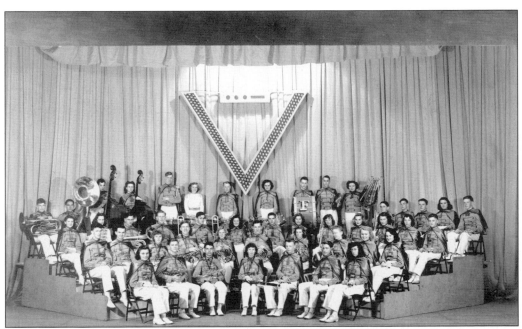

The Robert E. Fitch High School Band poses on the high school stage in 1944. The "V" for victory in the background pays homage to those fighting in World War II. From 1935 to 1947, under director Albert I. Dorr, the band participated in competitions across the Northeast. Dorr was killed on a band trip to Montreal in 1947, when he was struck by a car while crossing the street. The football field at the high school is named for him. (Ramona Pugsley Comrie.)

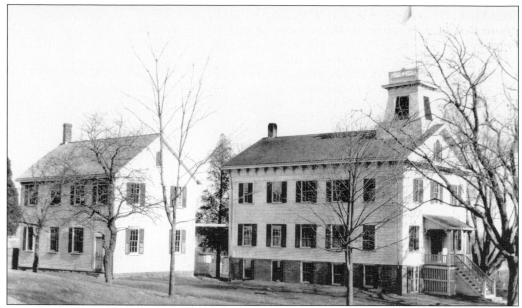

Mystic Academy was founded by John L. Denison in 1850 as a private school, and this building was erected in 1852 to accommodate 150 students. The school went bankrupt after the Panic of 1857, and the property was acquired by Groton's Fifth School District. In 1879, the population increase required a two-story addition to the school next to the main schoolhouse. (Carol W. Kimball.)

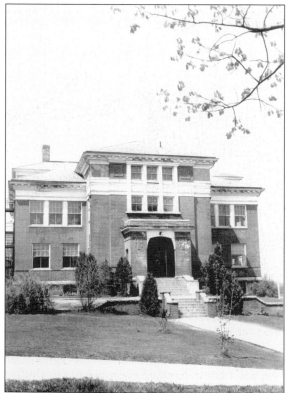

This three-story brick schoolhouse replaced the original Mystic Academy in 1910 on the same site. It served the village as a school until 1990. The original building is now part of Academy Point, a retirement facility. (Wes Greenleaf.)

West Mystic School was built in 1860 on Noank Road in response to the Maxson and Fish shipyard in West Mystic. It was built as a one-room school but was enlarged in 1869 because of the prosperity of the shipyard. The school served as a kindergarten after the S. B. Butler School opened in 1953. The last classes were held there in 1962. It was sold in 1982 and converted to a private residence. (Wes Greenleaf.)

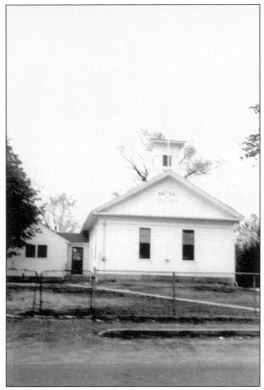

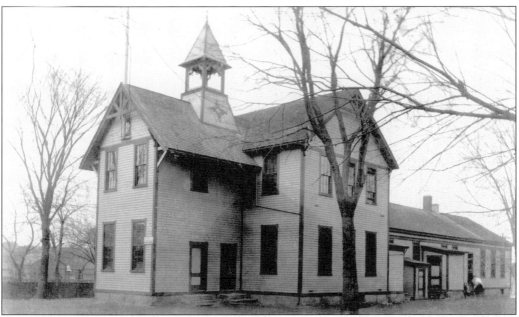

The old Noank schoolhouse stood on Main Street in the middle of the village on land that is now a playground. The school of District No. 11 was built in 1837 and was also used for meetings, prayer services, and funerals. The building housed kindergarten through eighth grade until 1949, when the current Noank school opened and this building was taken down. (Indian and Colonial Research Center.)

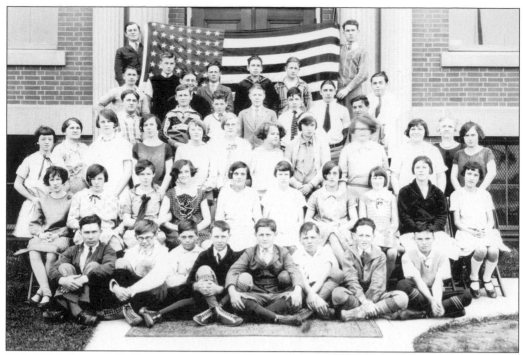

This 1926 photograph shows a class at the Groton Heights Grammar School. (Jim Streeter.)

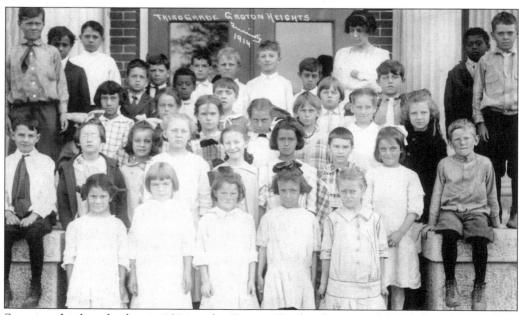

Seen is a third-grade class in 1914 at the Groton Heights Grammar School. (Jim Streeter.)

This 1905 photograph shows students at Poquonnock Bridge School. The original gambrel-roofed Seventh School District building was erected in 1797 and added to c. 1890. The building burned in November 1912, deliberately set afire by Roy Buddington (17), who was later placed in a mental hospital. (Carol W. Kimball.)

The brick school replacing the wooden schoolhouse was built on the same site as the Poquonnock Bridge School and was dedicated on December 2, 1913. Originally two rooms, it was enlarged over the years. In 1948, a new Poquonnock Bridge School was built, and the name of this school was changed to William Trail in honor of a longtime committee member of the Seventh School District. The school closed in 1959. It served as the town's first library, from 1960 to 1977. At present, it houses the town's social services agency. (Wes Greenleaf.)

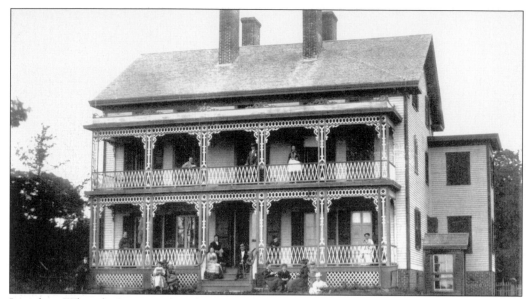

Jonathan Whipple Sr. opened a school for deaf mutes at his home in Quakertown, Ledyard, in 1871. He later moved to Mystic, occupying the former mansion of Silas E. Burrows, a world traveler and friend of presidents. The mansion was said to copy Burrows's home in Hong Kong. The school was reorganized in 1895 as the Mystic Oral School and was operated by the state of Connecticut until 1980. The original mansion was replaced by a number of brick buildings. (Carol W. Kimball.)

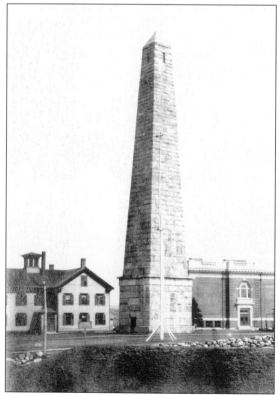

In 1912, the old wooden school at Groton Heights by the Groton Monument was replaced by a modern brick building. This c. 1912 photograph shows the new brick Groton Heights School to the right of the monument and the wooden school it was replacing to the left. The brick building, with additions, is still in use. (Jim Streeter.)

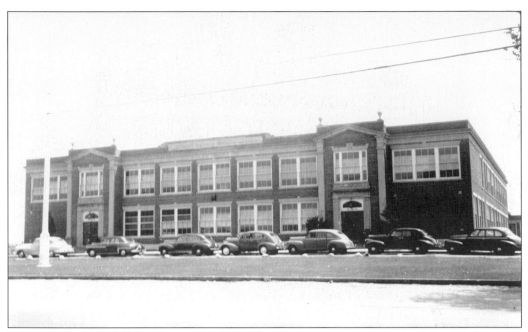

Robert E. Fitch High School opened in 1929. In 1926, businessman Charles P. Fitch offered the town $50,000 toward a high school if it were named for his son, Robert E. Fitch. The younger Fitch died at age 53 in 1922. He had been tax collector in the borough of Groton. Seen is the original Fitch High School building. It was replaced by the present high school on Fort Hill in 1955, and this became Fitch Junior High and later Fitch Middle School. (Wes Greenleaf.)

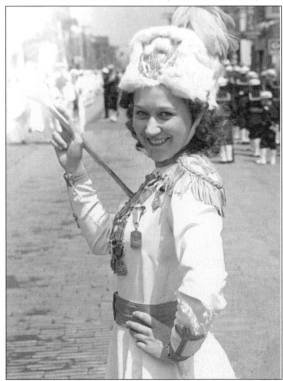

Lillian "Babe" Cate (Hansley) struts her stuff as the drum majorette of the Robert E. Fitch High School Band in this 1937 photograph. The band, under the direction of Albert I. Dorr, had a reputation for excellence throughout New England. (Colleen Temple.)

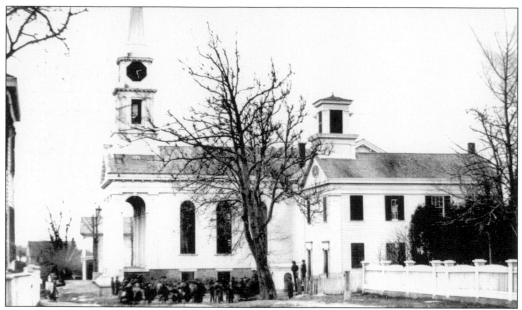

Portersville Academy, in Mystic, was built in 1839 by Amos Clift. In this 1870 photograph, the building stands next to the Union Baptist Church on High Street. It was abandoned as a schoolhouse in the 1870s. In 1887, the town purchased the building and moved it farther down High Street, where it was used to hold town and election meetings until 1958. In 1975, the Mystic River Historical Society acquired the schoolhouse and restored it. The building is opened regularly for schoolchildren to visit. (Carol W. Kimball.)

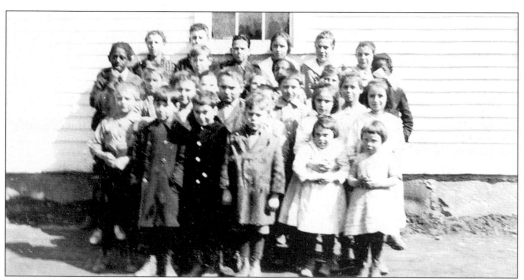

A class poses at Burnett's Corner School in Old Mystic c. 1920. From left to right are the following: (front row) Edward Pearce, Herbert Pearce, Wellington Hunt, Nadeen Hunt, and Silvia Gasparino; (middle row) Sam Lamphere, Nellie Lamphere, Ralph Comrie, Lilly Yetter, Albert Chesebro, Edward Comrie, Evelyn Sebastian, Walter Chesebro, Annie Lamphere, Clara Chesebro, Elsie Gasparina, Mary Chesebro, and John Sebastian; (back row) David Sebastian, Dan Chesebro, Frank Comrie, John Yetter, Lucy Chesebro, Lillian Lamphere, and O. Tizzani. (Marilyn Comrie.)

Five

BUSINESS

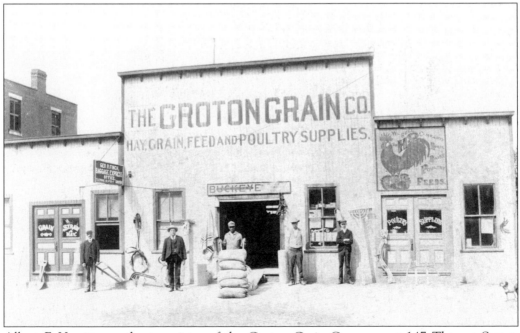

Albert F. Hewitt was the proprietor of the Groton Grain Company, at 147 Thames Street. He sold grain, feed, hay, and straw and was also the judge of the town court in Groton. This photograph was taken *c.* 1917. (Jim Streeter.)

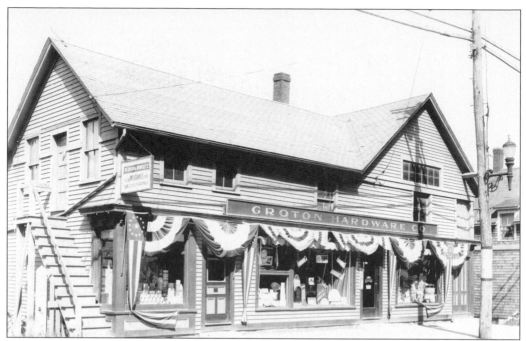

Groton Hardware, at 169 Thames Street, is shown in this 1930s photograph. The proprietor was John L. Couch. The white band on the utility pole in front signifies a trolley stop. The store was in business through the early 1960s. (Ann C. Brown and Barbara Parfitt.)

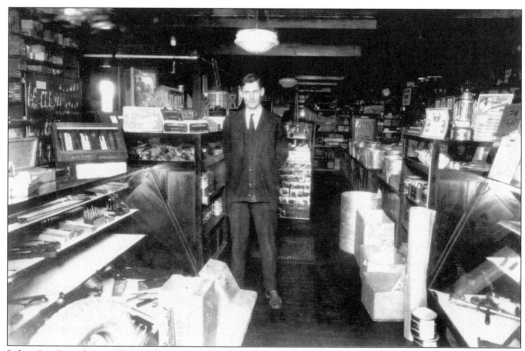

John L. Couch stands in the interior of his hardware store at 169 Thames Street. The shop sold housewares, toys, and marine hardware. It was also a fix-it shop. (Ann C. Brown and Barbara Parfitt.)

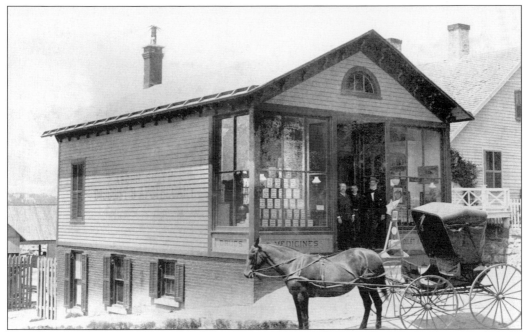

The Groton Pharmacy stood at Thames and School Streets. Its proprietor was C. S. Woodhull Davis, and in the 1917 directory, Davis said, "We are right at the ferry landing," which was at the foot of School Street. (Jim Streeter.)

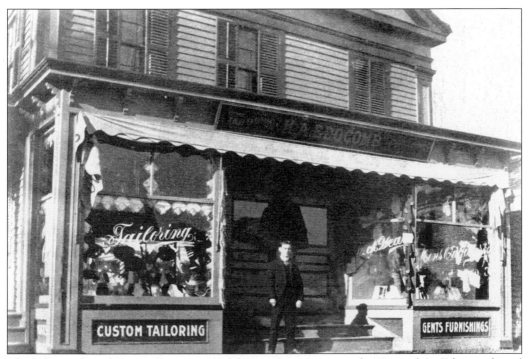

The Edgecomb and Poppe Store, at 137 Thames Street, was run by Howard A. Edgecomb and Irving H. Poppe, who was later town clerk. They specialized in clothing and men's furnishings. Paul's Pasta is in the building today. (Jim Streeter.)

George Hempstead and Son advertised in the 1917 directory that they were plumbers and tinsmiths doing business opposite the ferry slip in Groton. They were at 92–94 Thames Street. (Jim Streeter.)

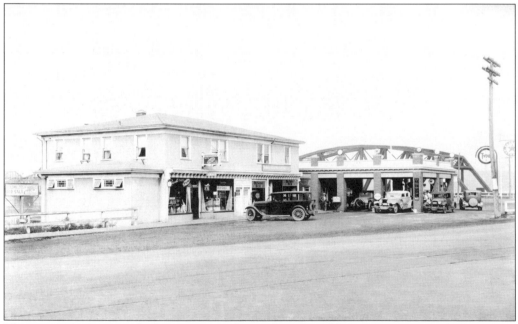

This c. 1935 photograph shows cars at the Bridge Plaza filling station on Bridge Street in Groton. The original vehicular bridge over the Thames River is on the far right in the photograph. That bridge was replaced by the cantilever Thames River Highway Bridge, which opened in February 1943. In 1951, the state legislature changed the name to the Gold Star Memorial Bridge in honor of those who died in World War II. (John Scott.)

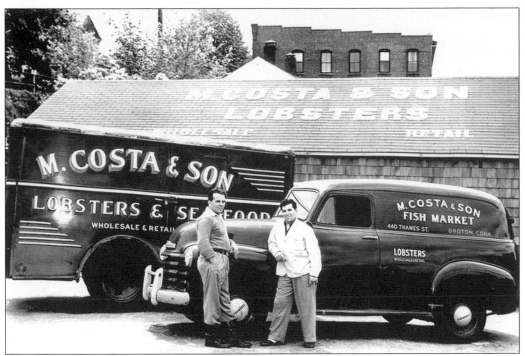

The M. Costa and Son market was a fixture on Thames Street along the Thames River. The family-owned business specialized in seafood, especially lobsters. (Ed Costa.)

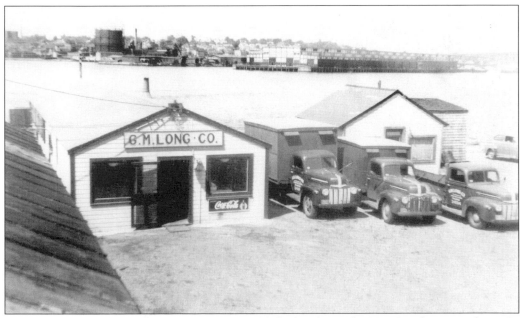

G. M. Long, a wholesale fish business, was established early on the New London waterfront. In the 1930s, it was a business in Groton. (Arthur Greenleaf.)

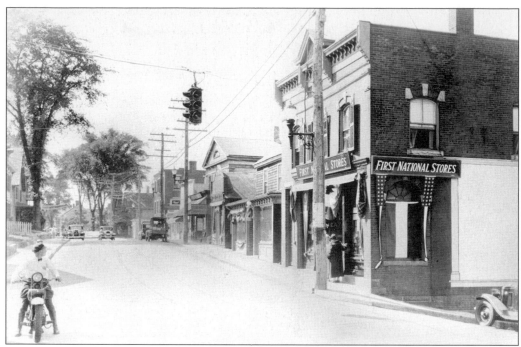

This 1930s photograph shows the First National market at 213 Thames Street. (Jim Streeter.)

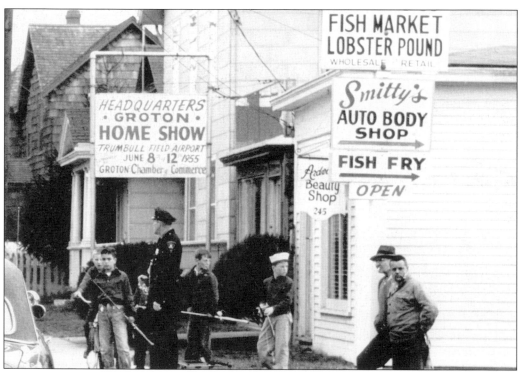

This 1955 photograph shows what a busy place Thames Street in Groton had become. (Jim Streeter.)

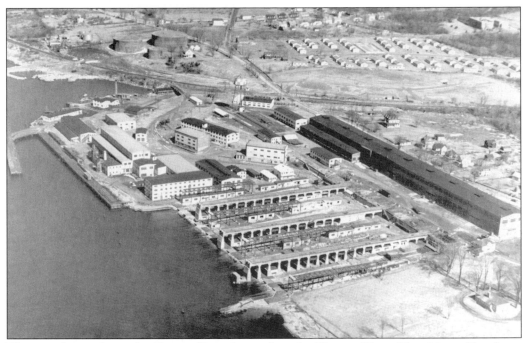

This aerial view shows the Electric Boat shipyard on the Thames River. The shipyard has been a significant part of the Groton economy and a major employer in town since World War I. Submarines are still built and repaired at the facility. (Jim Streeter.)

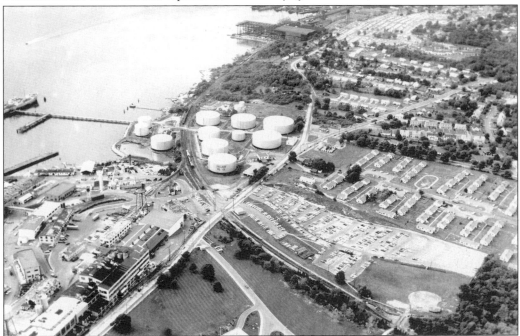

Just downriver from Electric Boat is the pharmaceutical company Pfizer, another of the region's major employers. One of Pfizer's main research laboratories is in its Groton plant. Former president Jimmy Carter lived in the housing project to the right of the tanks when he was stationed in Groton in the navy in the 1950s. (Jim Streeter.)

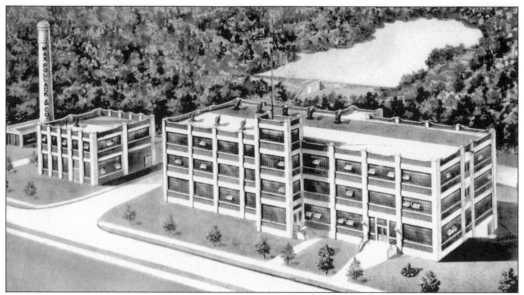

Seen is an architectural drawing of the Max Pollock and Company thread mill on Poquonnock Road. From 1920 to 1958, Max Pollock spun heavy thread for sewing baseball equipment and automobile upholstery. The company also made regular sewing thread. Today, the building is part of the Electric Boat Corporation. (Jim Streeter.)

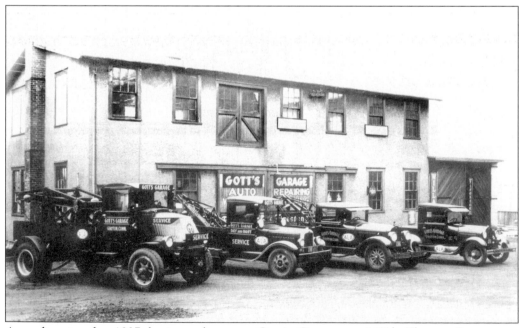

According to the 1937 business directory, Gott's Garage, at 169½ Thames Street, was established by Gottlieb G. Guhring and did automobile repairs. (Tom Migliaccio.)

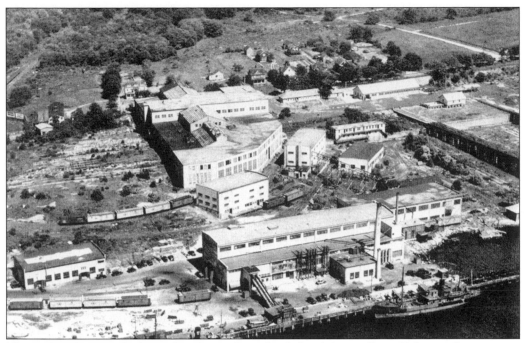

This 1930s photograph shows the Groton branch of the Atlantic Coast Fisheries Corporation of New York, which was on Eastern Point Road at the site later taken over by Pfizer. The wholesale business prepared fish for market. (Jim Streeter.)

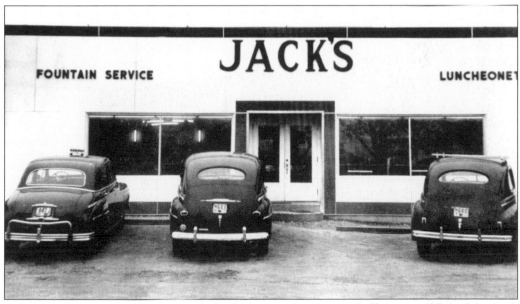

Jack's Luncheonette in Poquonnock Bridge across from town hall was established by Jack Fitzpatrick in 1930 because automobile traffic had increased dramatically along Route 1. It remained a popular eatery for many years. (Carol W. Kimball.)

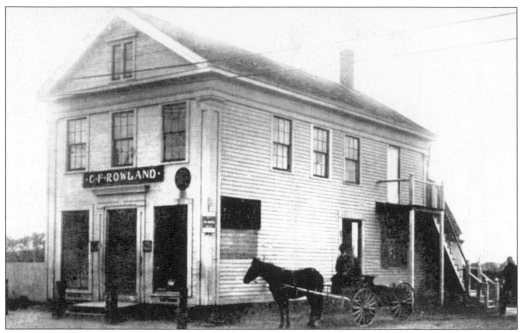

Charles Rowland sits in a buggy outside his grocery store in Poquonnock. The building, much changed, still stands on Poquonnock Road, also known as Route 1. (Carol W. Kimball.)

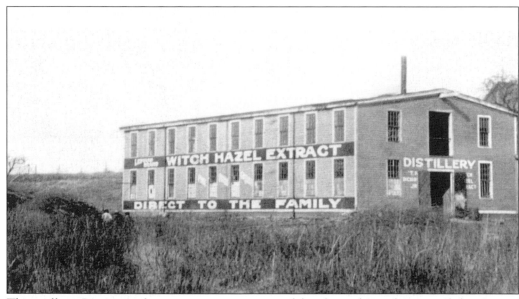

This mill in Poquonnock, on property now owned by the utilities division of the City of Groton, was expanded from the site of the original village gristmill. Between 1911 and 1917, Thomas N. Dickinson manufactured Ledyard brand witch hazel there. The copper stills he used are now in the Smithsonian. (Priscilla Pratt.)

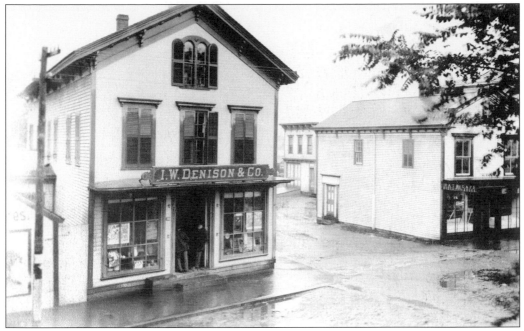

This *c.* 1900 view of West Main Street in Mystic shows the I. W. Denison and Company general store, which sold groceries and dry goods. The building and the one to the right are still used as storefronts today in the popular tourist village. The building in the background on Gravel Street is the old Mystic Hook and Ladder Firehouse, which was demolished in the early 1970s and replaced with a sewer pumping station for the town's new sewer system. (Carol W. Kimball.)

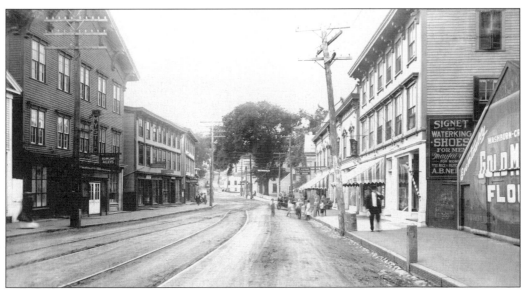

West Main Street in Mystic, shown after 1906 with the trolley tracks running down the center of the road, was as much the heart of the village's business district 100 years ago as it is today. (Carol W. Kimball.)

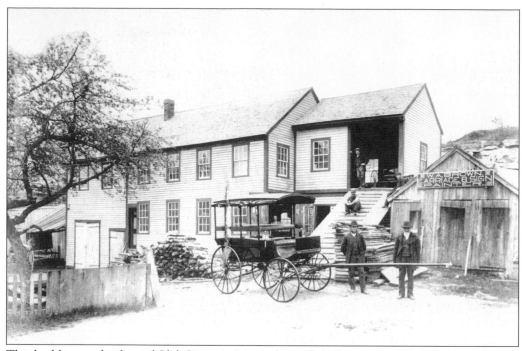

This building at the foot of Clift Street in Mystic housed the business of W. A. Brown, carriage and sign painters. The photograph dates from the late 19th century. (Carol W. Kimball.)

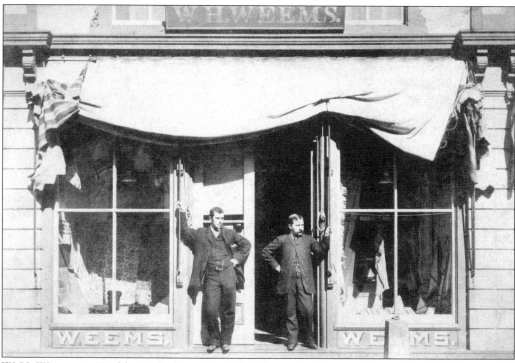

W. H. Weems, in Buckley's Block on West Main Street in Mystic, advertised in 1886 that it sold staple and fancy dry goods, notions, and Japanese willow ware. (Carol W. Kimball.)

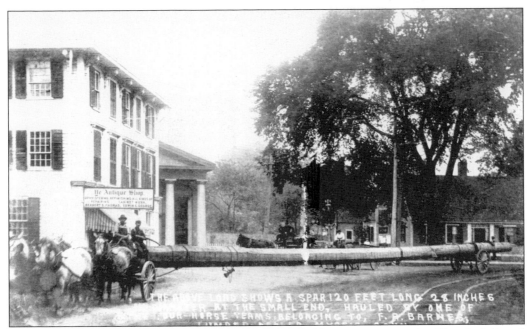

In this view of Bank Square in Mystic, a spar is probably on its way to the Noank shipyard around World War I. The building on the left was replaced by Chelsea Groton Bank in 1954. (Carol W. Kimball.)

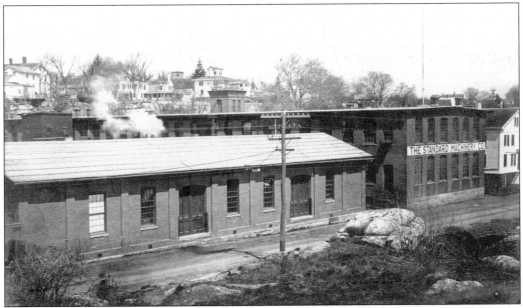

This photograph of the Standard Machine Shop, on Water Street, was taken *c.* 1930. The business was established as the Reliance Machine Shop in 1848 and became the Standard Machine Company after the Civil War, when it manufactured bookbinding machinery. In the 1940s, it made plastic molding presses. In 1961, the company affiliated with Crompton Knowles and moved to Stonington. Today, these buildings house condominiums, shops, and restaurants. (Carol W. Kimball.)

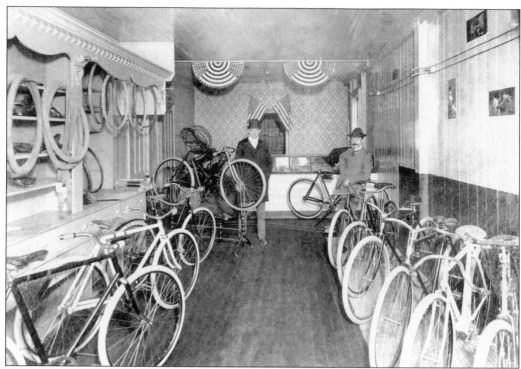

Seen is Nelson J. Baker's bicycle shop in Mystic in the 1890s. (Carol W. Kimball.)

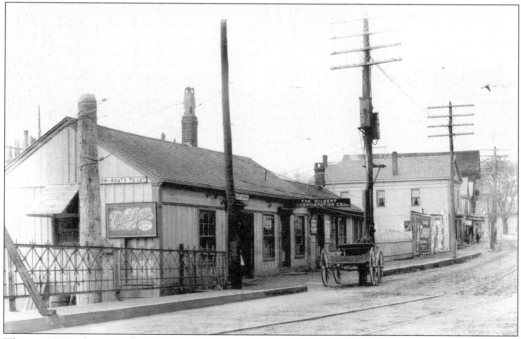

This c. 1906 photograph, taken at the west end of the Mystic Highway Bridge, shows the first office of the Gilbert Transportation Company, which later built a four-story brick building on the site. The building on the right was formerly William Bendett's store, which is still used as a store downtown today. (Indian and Colonial Research Center.)

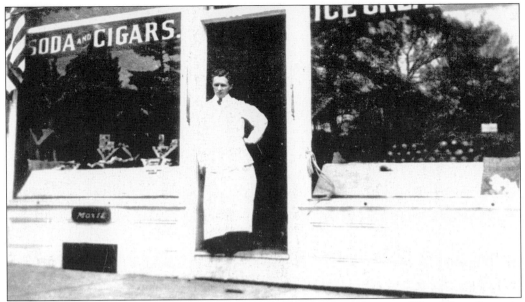

John G. Wheeler stands in the doorway of H. N. Wheeler's Drug Store, on West Main Street in Mystic. Wheeler's father, H. N. Wheeler, opened the drugstore in 1882, and his son took over in the 20th century. The store sold drugs and patent medicines and boasted a wonderful soda fountain. (Carol W. Kimball.)

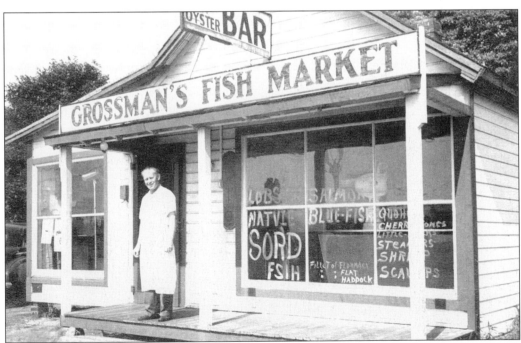

In this *c.* 1950 photograph, Otto Grossman stands outside Grossman's Fish Market, on Noank Road in West Mystic. Grossman built the market in 1924 and was famous for his misspellings, as can be seen in the store windows. Grossman retired in 1971, but the market (little changed since this photograph was taken) is still in business under Peter Danesi. (Carol W. Kimball.)

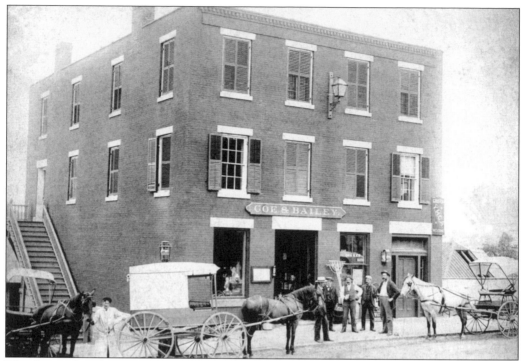

The Coe and Bailey store was on Thames Street at the end of Pleasant Street. The lower floor of this building has been occupied by various businesses throughout the years, while the upper floors housed the Groton Hotel until the late 1960s. (Kim Kohrs.)

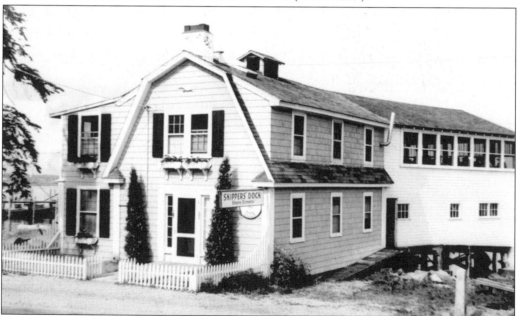

Skipper's Dock, in Noank, was one of the first seaside restaurants in the area. The building extended out over the water, and the wait staff dressed in white sailor suits complete with sailor hats. The building was badly damaged during the 1938 hurricane. Today, the site is a private residence. (Jim Streeter.)

Six

CHURCHES

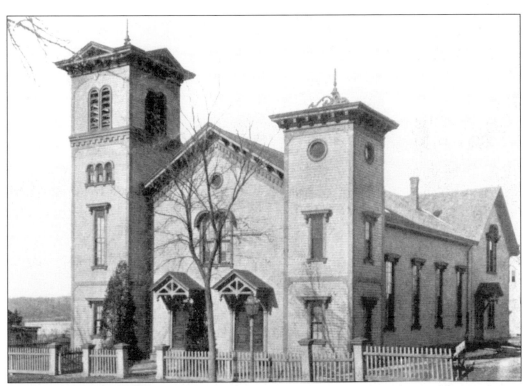

In 1843, a Baptist congregation was organized at Groton Bank, meeting first on Thames Street. In 1872, this church on Broad Street was dedicated and, in 1887, was renamed the Groton Heights Baptist Church. (Jim Streeter.)

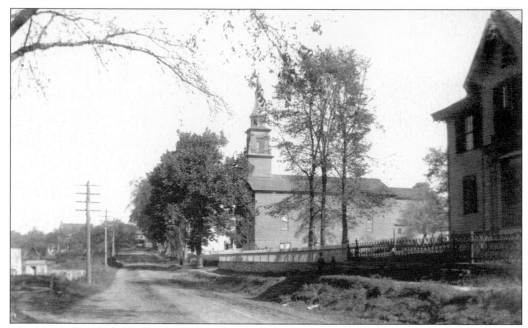

The original building of the First Church of Christ Congregational was in Center Groton. The third building, shown here, was built in 1833 on Upper Thames Street overlooking the Thames River to accommodate the residents of Groton Bank because the population of that part of town had increased significantly. (Carol W. Kimball.)

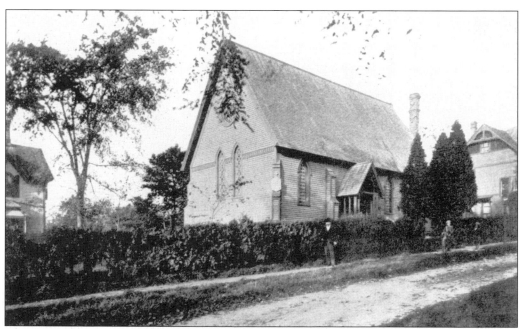

The first service at Seabury Memorial, at the foot of Fort Street in Groton, was held on Christmas Eve 1875. The building was an offshoot of St. James Episcopal Church in New London, and it was named for Bishop Samuel Seabury, the first bishop of the Anglican Church in America, who was born in Groton in 1729. (Jim Streeter.)

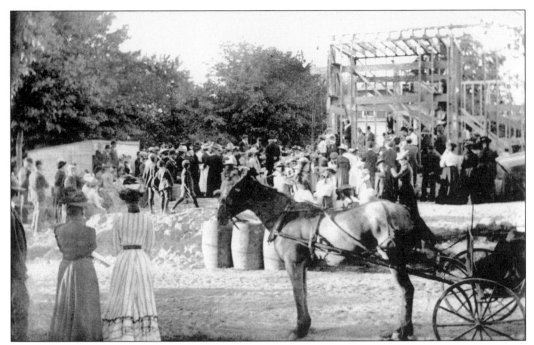

A crowd gathers for the laying of the cornerstone of the First Church of Christ Congregational, at 162 Monument Street in Groton in 1902. It was the fourth building the congregation would occupy and is still in use today. (Jim Streeter.)

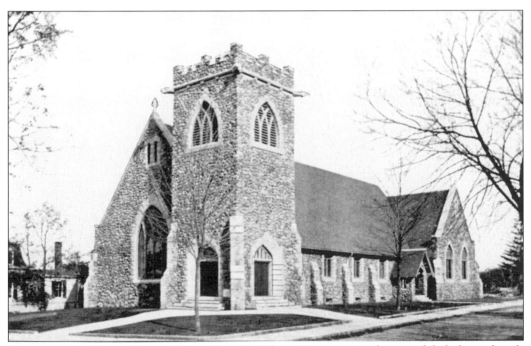

The present building of Groton's First Church of Christ Congregational was modeled after a church in Ipplepen, England, where the Groton Avery family came from, and was built from fieldstones collected from the homes of early members and historic sites in Groton. (Jim Streeter.)

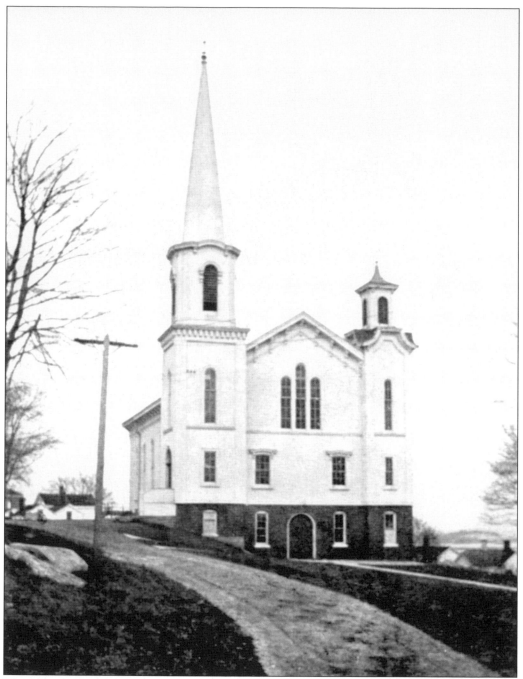

The Noank Baptist Church was formed in 1843, and this building was constructed in 1867. The congregation was formed from the Second Baptist Church on Fort Hill. The Noank Baptist Church has a commanding view of the mouth of the Mystic River, and its steeple can be seen far out into Fishers Island Sound. This building was destroyed by fire on Christmas Eve 1959. A new church was immediately built to take its place. (Jim Streeter.)

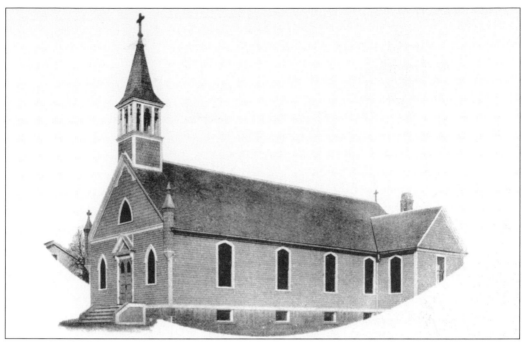

In 1903, with the Palmer Shipyard at its height in Noank, St. Joseph Roman Catholic Church was built on Front Street in the village. The interior of the church was featured in the opening scenes of the movie *Mystic Pizza*. Today, the building is a private home. (Jim Streeter.)

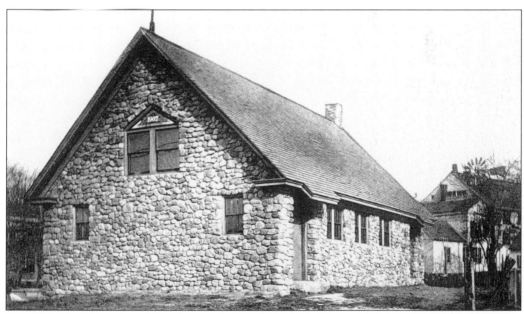

The Episcopal church in Noank was organized *c.* 1903. The cobblestone building on Sylvan Street is now the headquarters of the Noank Historical Society. (Jim Streeter.)

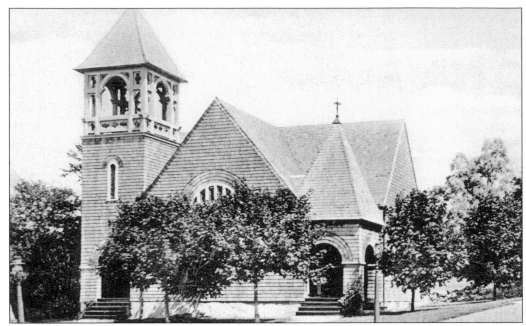

The Eastern Point Chapel was built for the convenience of summer visitors to the Griswold Hotel. (Jim Streeter.)

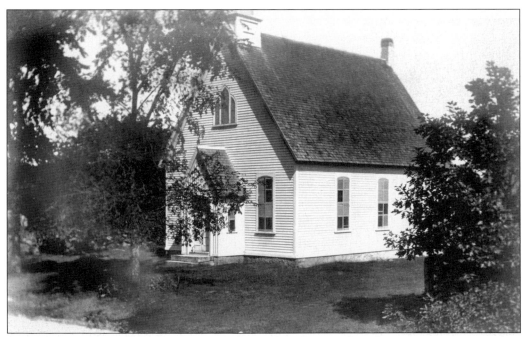

The Center Groton Chapel was typical of the chapels started in the 1890s to accommodate village populations far from urban centers. It stands on Candlewood Road and is now called the Grace Baptist Chapel. (Carol W. Kimball.)

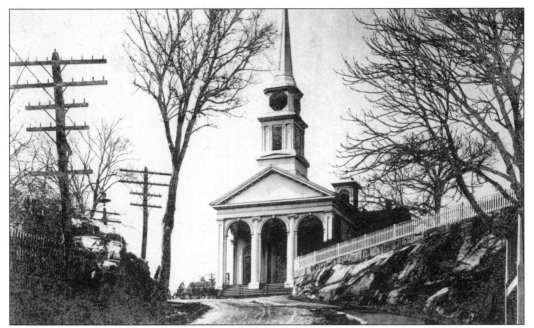

The Union Baptist Church has had a prominent place on Baptist Hill in Mystic since 1861, when the Second and Third Baptist Churches of Groton united buildings and congregations on the site of the Mariners Free Church. The steeple in this photograph was destroyed in the 1938 hurricane. A new steeple was erected in 1969. (Carol W. Kimball.)

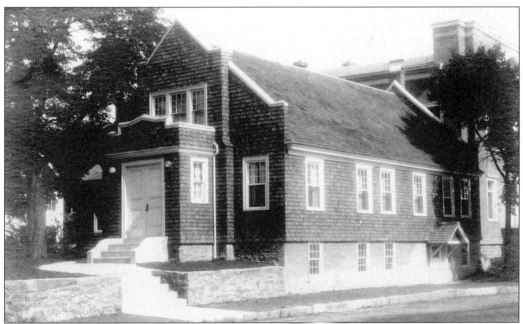

A group that met in the Gilbert Block in Mystic established the First Church of Christ Scientist in 1909. They remodeled a former sea captain's 1827 home built on Gravel Street into their church 10 years later. It is still in use by the congregation today. (Carol W. Kimball.)

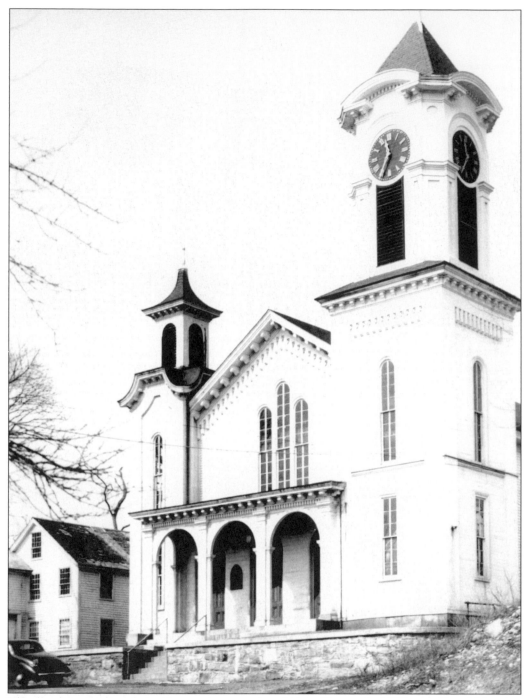

The first Baptist church in Connecticut was founded in Groton in 1705 with Rev. Valentine Wightman as its minister. This photograph shows the third building that served as the church, erected in 1844 on Route 27 in Old Mystic. The congregation has since built a new church on Shewville Road and changed its name to the Old Mystic Baptist Church. This building is now a private residence. (Jim Streeter.)

The Old Mystic Baptist parsonage was celebrated as the oldest Baptist parsonage in America. The property was presented to Valentine Wightman, the first minister of the First Baptist Church, by William Stark. The house was on Stark's Hill, which is near Watrous Avenue on Route 184. The house burned in 1926. (Carol W. Kimball.)

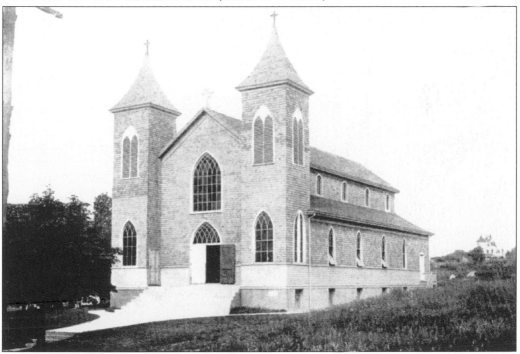

The original building of Sacred Heart parish was on Eastern Point Road. In the 1960s, the parish relocated to a new church with a parochial school on Sacred Heart Drive next to Colonel Ledyard Cemetery. (Jim Streeter.)

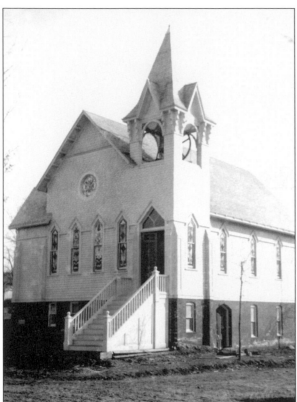

The Methodist church in Noank was formed as a chapel in 1878. The church building in this photograph was built in 1903 at Sylvan and High Streets. Christ United Methodist Church, on Hazelnut Hill in Groton, was built in 1972 and combined the Methodist congregations in Noank and Groton. (Indian and Colonial Research Center.)

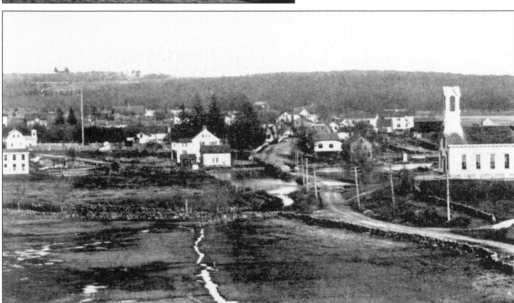

When the Second Baptist Church of Groton voted in 1845 to move from the top of Fort Hill to Mystic, the village of Poquonnock Bridge had to establish its own church. The congregation met in the conference room of the Poquonnock Bridge School until it raised enough money to build a church. The new church opened in 1871. This photograph of the village, taken c. 1900, shows the church on the right. The road is now part of Route 1. (Carol W. Kimball.)

Seven

TRANSPORTATION

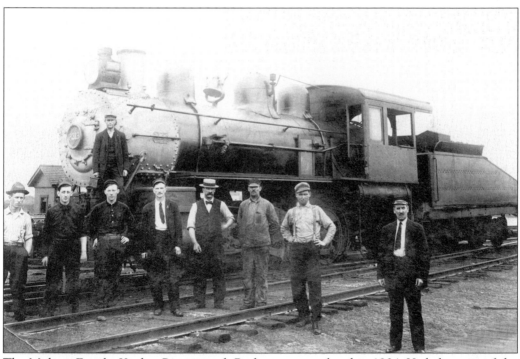

The Midway Freight Yard at Poquonnock Bridge was completed in 1904. Hailed as one of the greatest freight yards in New England, Midway was active until the Great Depression. By then, technology no longer required trains to stop to water engines. In this 1907 photograph are, from left to right, Tom McGuire, Bill Johnson, Tess Williams, Al Burgo, Whalen Church, Albert Exley, Ira Trail, and Louis Knowles. Art Kilpatrick is on the engine. (Mabel Exley Brown.)

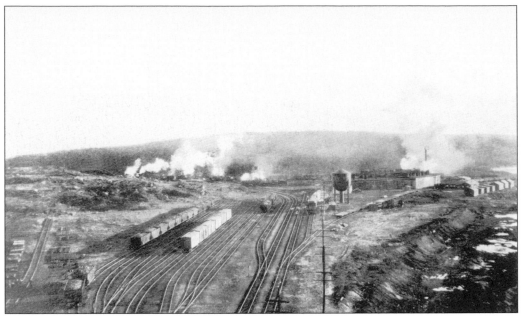

The level ground at Midway accommodated 20 miles of track with room for 40 complete freight trains. The facility also had a brick engine house that could accommodate 20 locomotives, a 75-foot turntable, a 2,400-ton coal pocket, a water tower, a refrigeration plant, and even the Midway Hotel to provide housing for railroad workers. (Thomas L. Hagerty.)

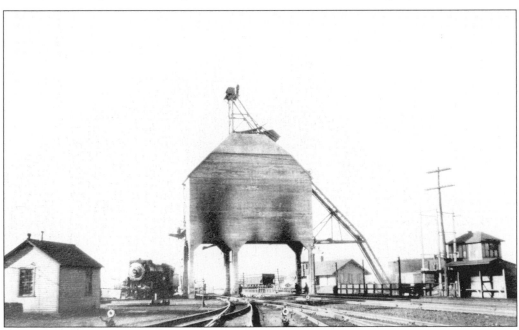

The huge railway freight yards of Midway at the end of Depot Road in Poquonnock Bridge were built to allow the engines of the day to refuel by taking on water and coal at the halfway point between New York and Boston. The coal station in the center of this photograph was erected in 1926. The massive freight yard operated for nearly 30 years and employed everyone in Poquonnock Bridge. (Thomas L. Hagerty.)

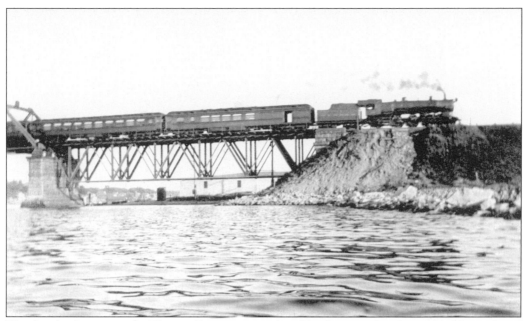

The first bridge across the Thames River was a railroad bridge completed in 1889. The railroad had to lay five miles of double track from Poquonnock to the river crossing. In 1919, a new railroad bridge was built across the Thames, and the state converted the old bridge to the first highway bridge across the river. (Jim Streeter.)

The old Groton railroad station, which stood at the end of Thames Street, was built to accommodate New York, New Haven and Hartford Railroad passenger and freight traffic when the railroad bridge across the Thames opened in 1889. (Jim Streeter.)

Roswell Brown's livery stable was at Bank Square in Mystic for more than 70 years. Brown founded the business on Water Street *c.* 1850. His son, James E. F. Brown, joined him in 1883. The livery and boarding stable, shown here in 1907, had 24 stalls. It provided carriages to and from the railroad station. The property was later the site of Albertus B. Brown's automobile storage and Wally's Service Station. (Indian and Colonial Research Center.)

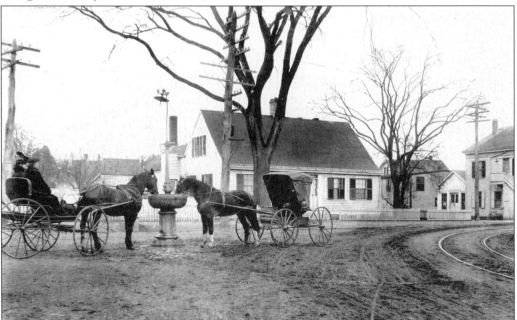

Horses drink from the horse trough at Bank Square in Mystic in this 1907 photograph. The trough was likely a victim of a scrap metal drive during World War II. The Cape Cod house was the home of widow Peace Grant at the corner of Pearl and West Main Streets. It was taken down in the 1920s and replaced by a store. The buildings on the right on Pearl Street are still there. (Indian and Colonial Research Center.)

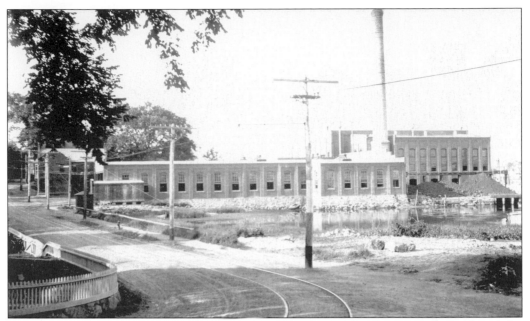

The power source for the Groton and Stonington Street Railroad was on the banks of the Mystic River. The brick powerhouse, with its 125-foot-high smokestack and coal-fed boilers, is on the right. The carbarn is just to the south. In the foreground, the trolley track curves around from Noank Road on to Water Street. Today, the powerhouse has been converted to condominiums. (Indian and Colonial Research Center.)

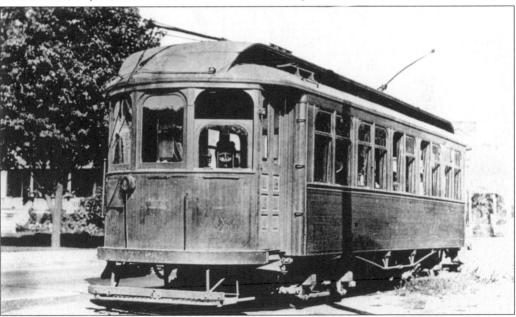

Before automobiles became prevalent, trolleys were a popular mode of transportation. This Groton and Stonington line trolley travels through Mystic. Each day, the first car left Mystic at 5:03 a.m. with hourly service until 8:00 a.m. and halfhourly service after that. The trip from Westerly, Rhode Island, to Thames Street in Groton took 1 hour and 25 minutes. People took the cars to work and to shop, and students rode them to school. (Carol W. Kimball.)

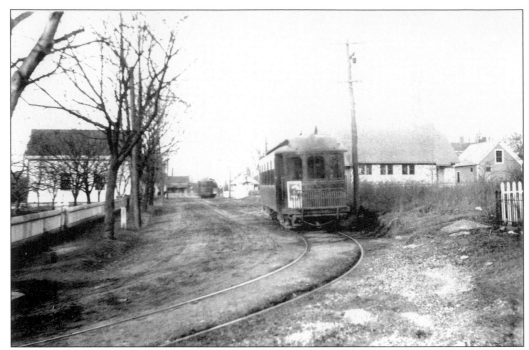

Here, a car of the Groton and Stonington Street Railway passes along Sylvan Street in Noank. The trolley line from Poquonnock to Mystic was completed on December 3, 1904. Trolleys were replaced by buses on June 4, 1928. (Indian and Colonial Research Center.)

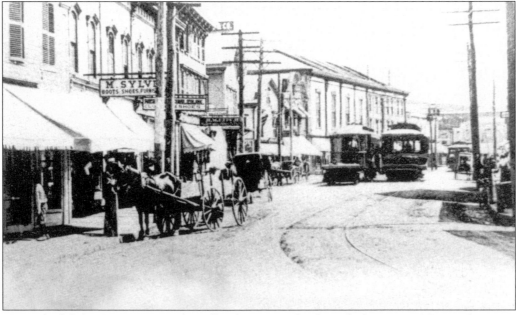

Not only did the Groton-Westerly trolley line run right through downtown Mystic, there was initially a double-track trolley switch in the middle of West Main Street at Gravel Street. West Main Street, shown here shortly after 1906, shows two trolleys at the switch. As automobiles became more prevalent, however, the switch was moved to Lincoln Avenue, a side street on the other side of the Mystic River. (Carol W. Kimball.)

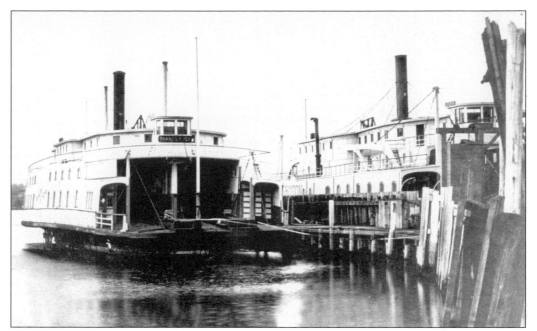

When the railroad first crossed Groton in 1858, the technology did not exist to build a bridge across a river as wide and deep as the Thames. So the Stonington Railroad used ferries to carry the train cars between Groton and New London. This 1876 photograph shows the ferries *Thames River* and *Groton* docked at the present site of Electric Boat. Author Charles Dickens once traveled aboard the railroad ferries, calling it a most unpleasant ride. (Jim Streeter.)

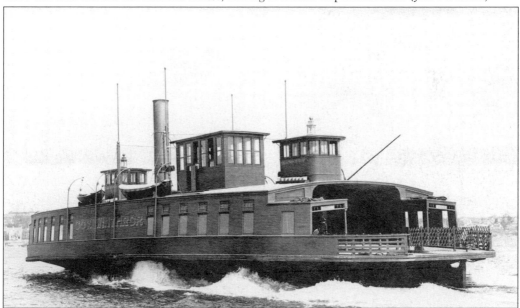

The *Governor Winthrop*, a 134-foot vessel built at the Palmer Shipyard in Noank, went into service in 1905. The steamer carried the first autos across the river. Ferries had crossed the river since 1651, leaving from Thames Street at the foot of School Street and landing near the present site of the New London Railroad Station. Ferry service continued until 1929. (Carol W. Kimball.)

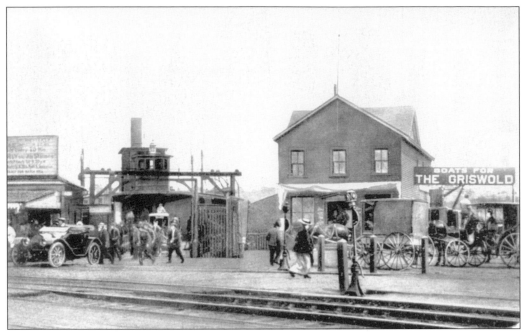

Until the 1920s, ferries were the only way for passengers, wagons, and motor vehicles to cross the Thames River. This early-20th-century photograph shows the ferry landing in New London behind the railroad station. To the left of the building is the commercial ferry landing, and to the right a sign directs passengers to boats going to the Griswold Hotel in Groton. (Jim Streeter.)

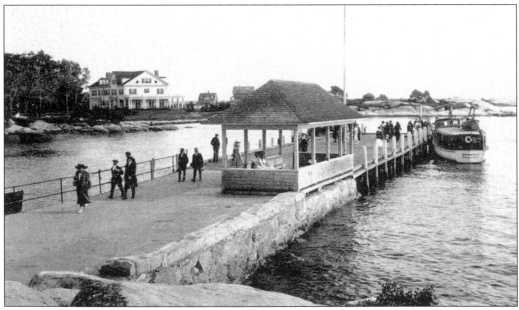

The visitors' landing at the Griswold Hotel in Eastern Point shows guests boarding one of the boats that ferried them from the train station in New London to the elegant summer hotel in Eastern Point in Groton. Hotel owner Morton Plant had boats built for the hotel to provide the service. The boats even had their own dock on the New London side of the river. (Jim Streeter.)

The advent of the automobile forced many changes to the town's quiet streets. In Mystic, construction workers in 1924 create a new road up Baptist Hill, extending Main Street to connect it with New London Road at Elm Street. Workers here blast rock to cut the steep hill down at least 10 to 12 feet, to a grade that early automobiles could maneuver. (Lou Martell.)

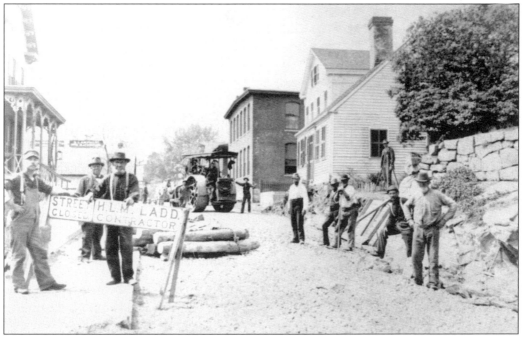

Workers prepare to lay the trolley track on Water Street in downtown Mystic in 1903. The state legislature authorized the route for the trolley on August 17, 1903, and work began shortly after. The two-story brick building in the center of the photograph is the former Standard Machine Company, today Factory Square. (Carol W. Kimball.)

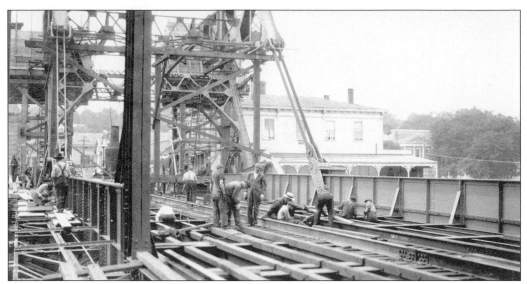

Workers build Mystic's famous bascule bridge, which carries Route 1 across the Mystic River. The structure boasts an 88-foot finely balanced lift and is one of Mystic's most popular tourist attractions. The structure, which opened on July 19, 1922, cost $254,000 to construct and was paid for by the towns of Groton and Stonington and the state of Connecticut. (Jack Vibber.)

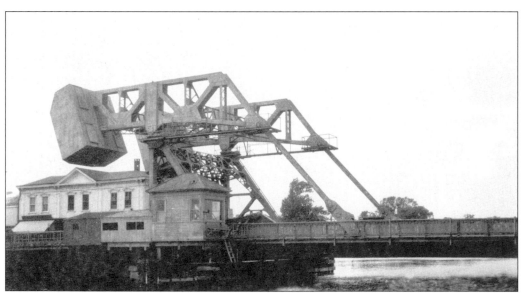

The Mystic drawbridge opens hourly to allow boat traffic up and down the Mystic River. (Jim Streeter.)

In early Groton, the crossroads of present-day Routes 184 and 117 was the geographical center of town, when Ledyard was part of Groton. Steven Russell Smith built a tavern and stagecoach stop at the crossroads that later became known as the Haley house. When the state decided to widen Route 117 in the 1980s, Ruth Keyes moved the house to Welles Road in Old Mystic. It is now Haley Tavern at Red Brook Inn. (Jim Streeter.)

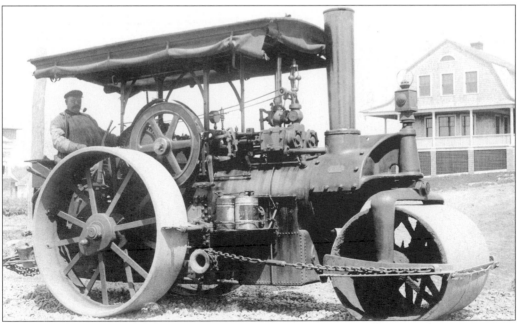

This vintage steamroller prepares to build roads in the Eastern Point section of Groton. (Jim Streeter.)

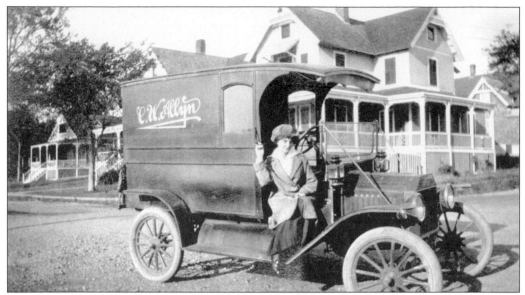

This delivery truck was a familiar sight in Groton Bank during the 1920s. It belonged to Carlos W. Allyn, who ran a grocery store at 129 Thames Street, a store that was handy to the ferry landing. (Jim Streeter.)

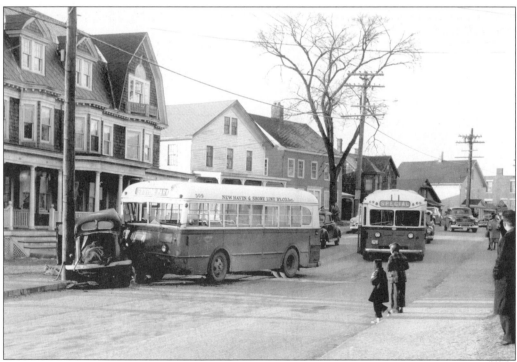

The Groton–New London trolleys discontinued service in June 1928, replaced the following month with a bus service. In December 1938, the Groton-Stonington bus line was acquired by the New Haven and Shoreline Railway, and the name was changed to New Haven-Shoreline Buses. This photograph shows an accident between one of the buses and a car on Thames Street in Groton. The bus service was discontinued after 1960. (Jim Streeter.)

The *Summer Girl* chugs down the Mystic River in this World War I–era photograph, which shows a wooden bridge in the background spanning the river in downtown Mystic. That bridge was replaced in 1922 by today's bascule bridge. The *Summer Girl* traveled among the shoreline resorts, including Mystic, Ram Island, New London, and Watch Hill, Rhode Island. (Carol W. Kimball.)

The Ram Island Lightship was located just off Noank at Ram Island, the site of a popular summer hotel in the late 19th century. The ship served as a beacon and aid to navigation for the steamers of the Stonington line traveling Fishers Island Sound to New York. It was manned by a captain, mate, four seamen, and a cook. The schooner was replaced in 1925 by an automatic gas lantern. (Carol W. Kimball.)

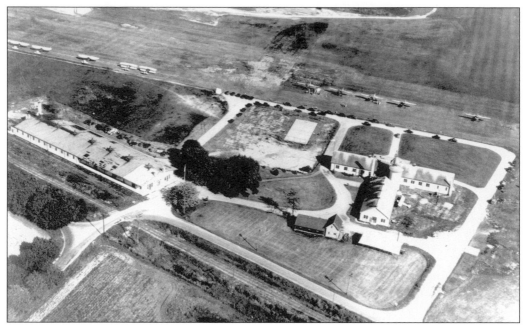

In March 1928, the state of Connecticut optioned 275 acres of Morton Plant's estate bordering the Poquonnock River and Baker's Cove for the Connecticut National Guard Air Squadron. Trumbull Airport, as it was named, was also used for commercial flights. This aerial photograph shows the early airport with its sod runways, outbuilding, and early aircraft lined up. The facility was renamed Groton-New London Airport in the 1960s. (Carol W. Kimball.)

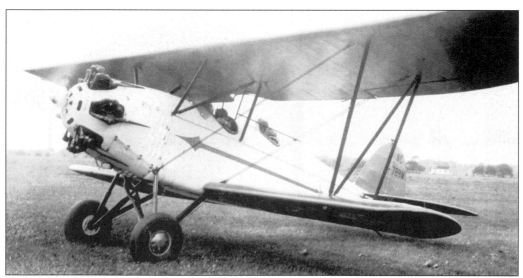

An early airplane sits at Trumbull Airport in Groton. The small airport was named for Gov. John H. Trumbull, a licensed pilot. Trumbull flew a plane to the airport for an informal inspection on July 20, 1928, and collided with another plane as he was about to land. He later joked that the crash "was all in a day's work." During World War II, the airport was first a training base for the Army Air Forces, but in 1944, it was taken over by the U.S. Navy. (Jim Streeter.)

Eight

RECREATION

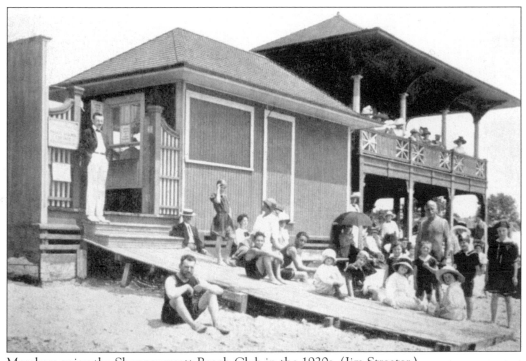

Members enjoy the Shennecossett Beach Club in the 1920s. (Jim Streeter.)

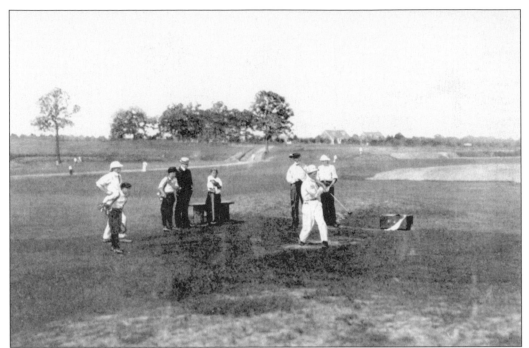

This view is of the early days at the Shennecossett Golf Course, which was founded in 1898 by Thomas Avery and expanded into an 18-hole course by Morton Plant in 1913–1914. In 1926, the course was redesigned by the nationally famous Donald J. Ross. The town government of Groton acquired the property in 1968, and it has been a municipal golf course since then. (Jim Streeter.)

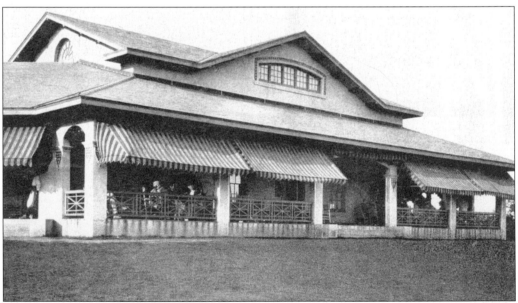

The first clubhouse at the Shennecossett Golf Club opened on June 9, 1914. This photograph was taken c. 1950. (Jim Streeter.)

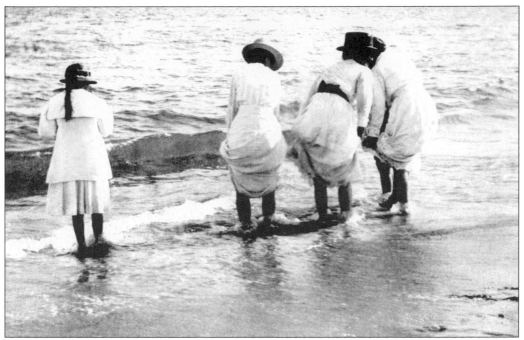

Women and girls wade at Bluff Point during the Poquonnock Bridge Sunday school picnic c. 1900. The annual community affair featured clam chowder, fish chowder, watermelon, and ice cream. (Groton Public Library.)

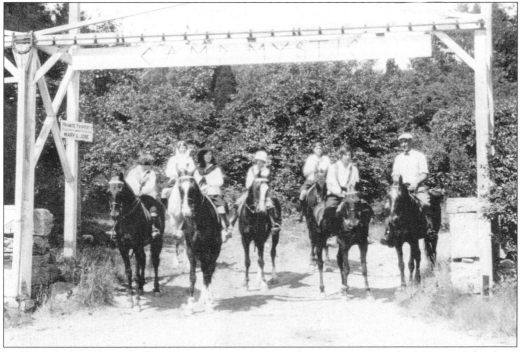

Young girls ride through the gate at Camp Mystic. The camp was run by Mary L. Jobe from 1916 to 1930 on the former site of the peace meetings. Jobe, who was a pioneer in the outdoor camping movement for girls, later married African explorer Carl Akeley. (Carol W. Kimball.)

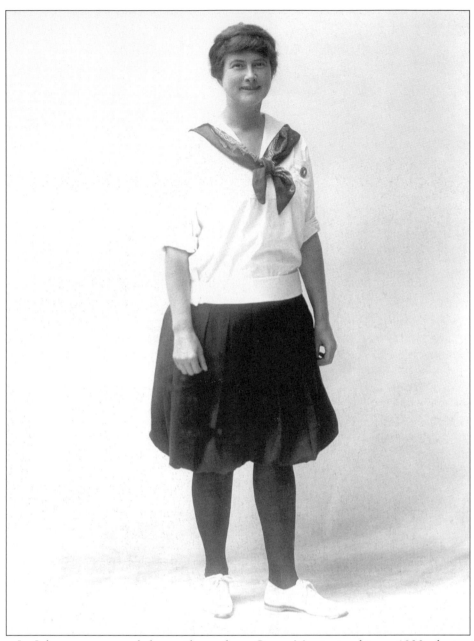

Mary L. Jobe wears one of the uniforms from Camp Mystic in this *c.* 1920 photograph. Although known locally for the girls' camp she ran from 1916 to 1930 on land along the Mystic River, Jobe was an explorer, mountain climber, author, and photographer. She later became the wife of Carl Akeley, for whom the African hall at the Museum of Natural History in New York is named. Jobe went on her first expedition while a student at Bryn Mawr College in Pennsylvania. The trip to the Canadian Rockies *c.* 1902 would be the first of many she would make there in coming years. She provided the Canadian government with the first reliable map of uncharted territories near the Fraser River and Mount Sir Alexander. In turn, Canada named a peak in the region—Mount Jobe—in her honor. She also photographed and studied the Gitksan and Carrier Indians of British Columbia. (Carol W. Kimball.)

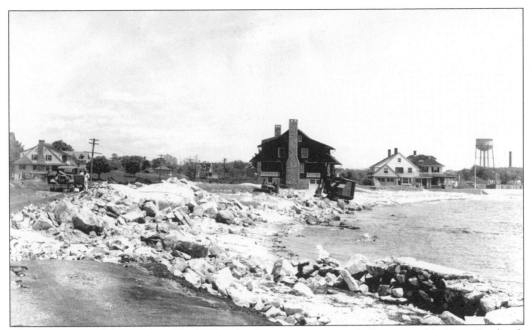

The hurricane of September 21, 1938, was the greatest natural disaster to hit New England, and Groton received a heavy blow. Here is a portion of Shennecossett in the aftermath of the storm. (Bill Sanford.)

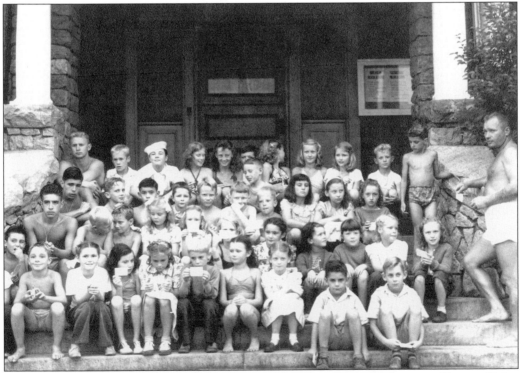

Youngsters pose for the camera after receiving their swimming certificates at Eastern Point Beach in the City of Groton. (Bill Sanford.)

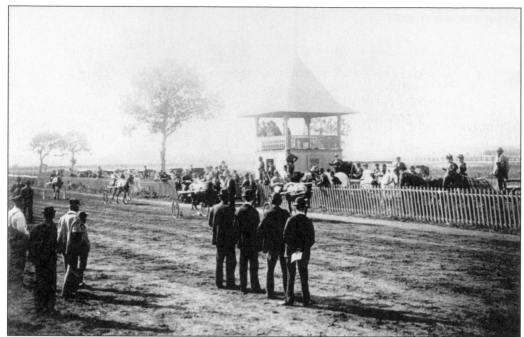

The Groton Driving Park was established at Poquonnock Bridge in 1891 for trotting races. It was on 20 acres just west of the present Sutton Park on Route 1. Poquonnock Plains was the only level land in Groton and was perfect for the racetrack. The facility included a 600-seat grandstand, the track, and box stalls. The track was also the site of baseball games and motorcycle races. The advent of the automobile put an end to the track in the World War I era. (Mystic Seaport.)

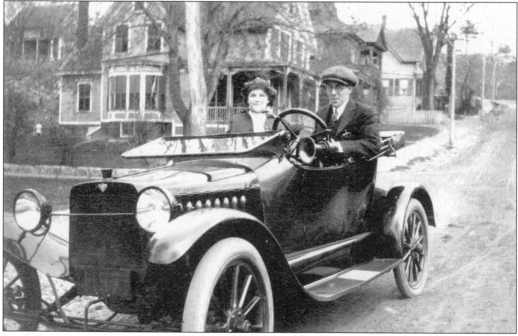

Frank Coe and a lady friend take a spin in his automobile in this 1912 photograph. (Jim Streeter.)

Members of the drill team, Mystic Grange, Patrons of Husbandry, assemble in full regalia for a celebration *c.* 1930. (Carol W. Kimball.)

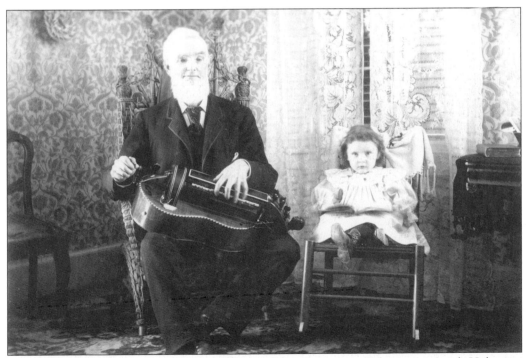

Mr. Hall of Old Mystic plays some music on a stringed instrument for a young girl, Helen, in this *c.* 1895 photograph taken by Elmer Waite of Burnett's Corners. Hall was a neighbor of Waite's. (Indian and Colonial Research Center.)

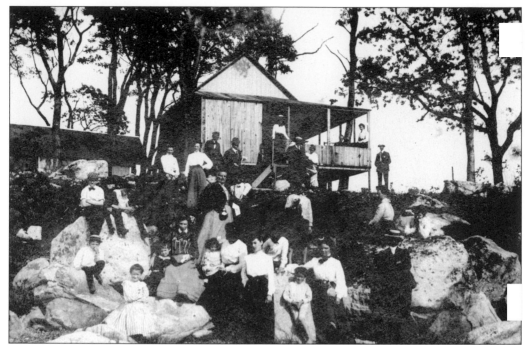

Before the 1938 hurricane, there were more than 100 summer cottages at Bluff Point on land owned by Henry Gardiner. The point was a popular place for summer picnics, as seen in this photograph of a family picnic near the shore. The hurricane destroyed all the cottages, and Gardiner never allowed them to be rebuilt. Today, Bluff Point is a coastal preserve owned by the state of Connecticut. (Dorothy Ann Peckham Morrison.)

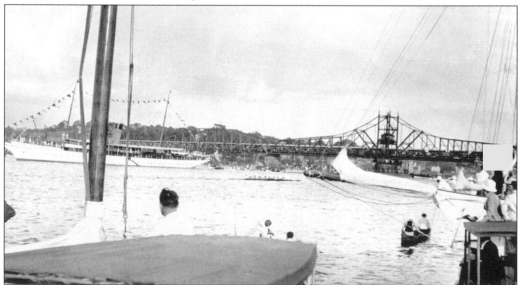

The Thames River is home to America's oldest intercollegiate sporting competition—the Yale-Harvard rowing regatta. Begun in 1852 and held on the Thames River since 1878, the boat races between the two Ivy League schools draw huge crowds to the river each June. In the early part of the 20th century, as this photograph shows, yachts and spectator boats crowded the river to watch the shells. (Jim Streeter.)

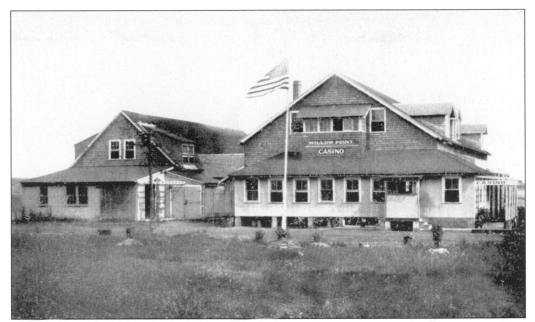

The Willow Point Casino at West Mystic was a recreational dance hall built by Silas Maxson in 1915. The term casino had nothing to do with gambling. It was a place for socializing and dancing, and people came by trolley to enjoy the entertainment. The casino burned in 1931 and is remembered today only by Casino Road. (Carol W. Kimball.)

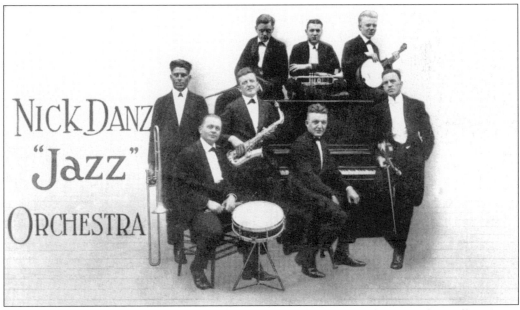

The Nick Danz Jazz Orchestra was one of the groups that played for dances at the Willow Point Casino. The pianist was blind. The group advertised itself as having "music that would lighten a cemetery." (Carol W. Kimball.)

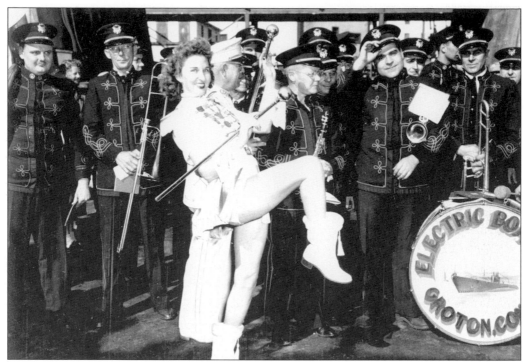

The Electric Boat band played for launchings and other important occasions. (Electric Boat Corporation.)

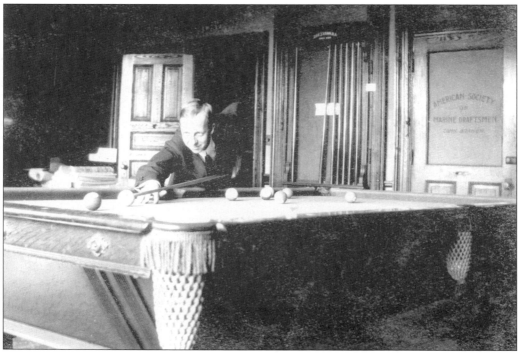

The Marine Draftsmen Association pool and recreation room at Electric Boat provided respite for workers with this elaborate pool table. (Jim Streeter.)

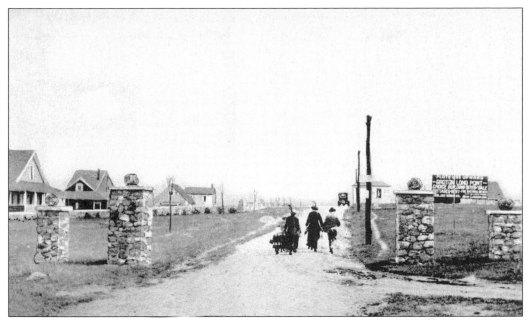

In 1912, a New York entrepreneur began a private summer enclave at Groton Long Point, building and selling houses that still have private roads, a casino, and their own private beach. This 1912 photograph shows the entrance to Groton Long Point and some of the early houses built there. (Jim Streeter.)

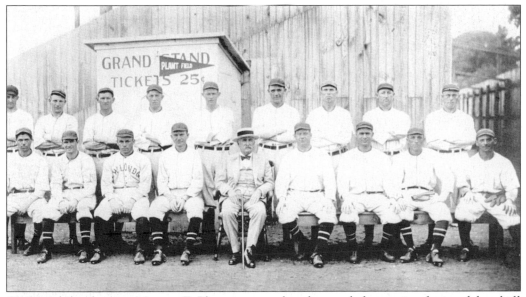

Groton philanthropist Morton F. Plant sponsored and owned the semiprofessional baseball team the Planters. They were the champions of the Eastern Association in 1914. Here, Plant poses with the winners. The team played at Plant Field in New London. (Jim Streeter.)

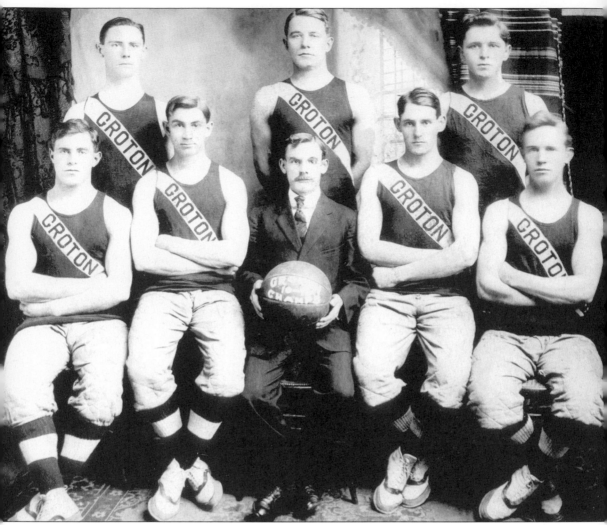

This view of an early-20th-century champion basketball team from Groton indicates only the last names of the star athletes. From left to right are the following: (front row) Newbury, Tomlinson, Poppe (manager), Edgecomb, and Archer (captain); (back row) O'Brien, Forbes, and Needham. (City of Groton Parks and Recreation Department.)

Nine

AROUND TOWN

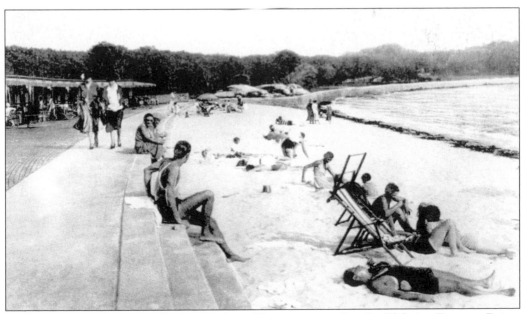

Bathers enjoy the sun and the sand at Shennecossett Beach Club in Eastern Point. (Jim Streeter.)

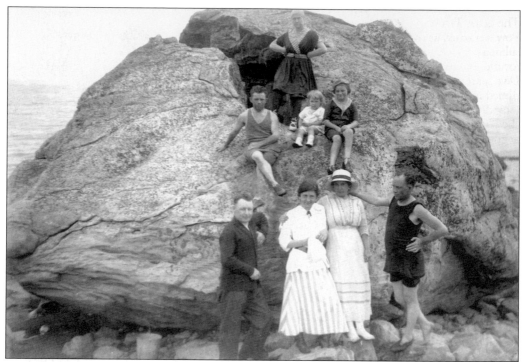

A family leans against Split Rock, long a landmark at Bluff Point, during a picnic there in the early 1900s. (Groton Public Library.)

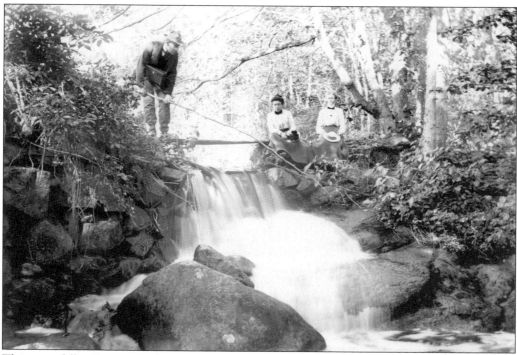

This waterfall at Poquonnock was once a popular recreation spot. Today, it is part of the Groton Utilities watershed property. (Indian and Colonial Research Center.)

The actor Tyrone
Power trained at the
submarine base in 1942
for the movie *Crash
Dive*, part of which was
filmed in Groton. Power
(standing second from
the left) is pictured
at the escape training
tower with enlisted
personnel in 1942,
including Carl Bryson
(seated on the left), who
kept the photograph as a
souvenir. (Carl Bryson.)

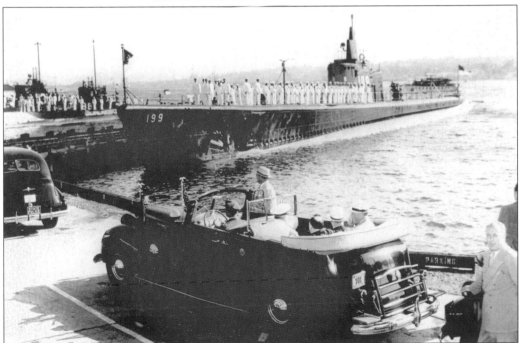

Pres. Franklin Roosevelt, seated in the back right seat of the automobile, visits the submarine
base *c.* 1940. Sailors stand at attention aboard the USS *Tautog* (SS 199) in the background. In
World War II, the *Tautog* sank 26 enemy ships. (Carl Bryson.)

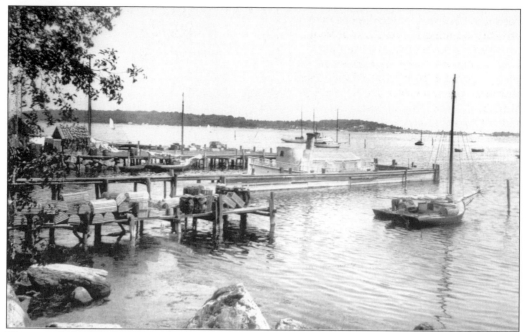

This *c.* 1907 photograph shows the docks and wharves at Noank, which was a busy fishing village during that era. (Indian and Colonial Research Center.)

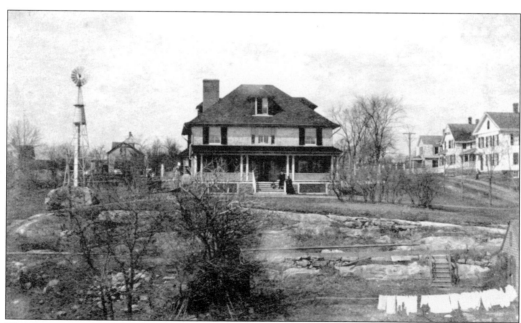

This house overlooking the mouth of the Mystic River in Noank was once owned by the famous American Impressionist Henry Ward Ranger. Ranger was an important figure in the artist colonies in southeastern Connecticut at the turn of the century. (Carol W. Kimball.)

For years, Charles Q. Eldredge operated a private museum on River Road in Mystic to exhibit his collection of more than 7,000 souvenirs. The exhibit included everything from ships' logs to three-legged chickens. The museum, built by Eldredge himself, attracted visitors from far and wide. It closed at his death in the 1930s. (Carol W. Kimball.)

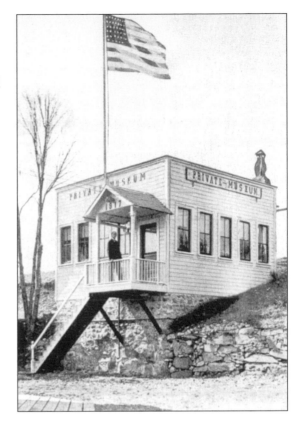

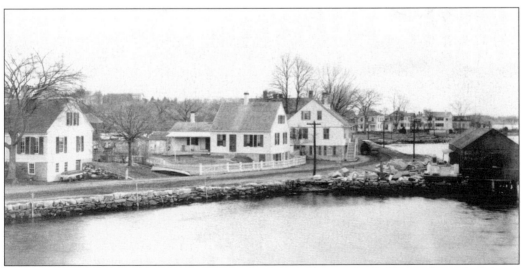

This *c.* 1920s scene of Gravel Street in Mystic shows three captain's houses along the Mystic River. On the right, at water's edge, is the Trevena Monument works. (Carol W. Kimball.)

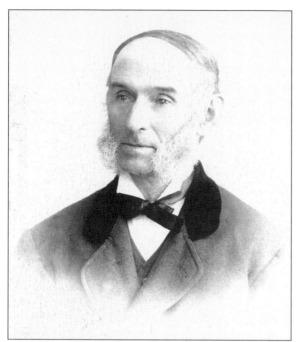

Capt. Charles Ferguson was a boatbuilder in early-20th-century Groton. He lived on Thames Street. (Jim Streeter.)

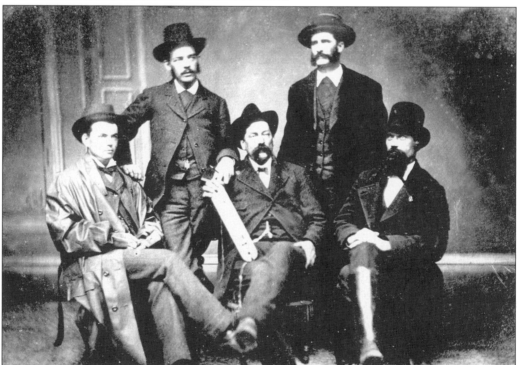

Capt. Hibbard Chester, pictured holding an anchor he invented, was first mate on the ill-fated *Polaris* North Pole expedition in 1871 under Charles Francis Hall. After *Polaris* was trapped in ice, Chester and part of the crew were stranded on an ice floe before finally being rescued near Greenland. Chester was born in Noank in 1837, and his house still stands on Main Street in that village. (Indian and Colonial Research Center.)

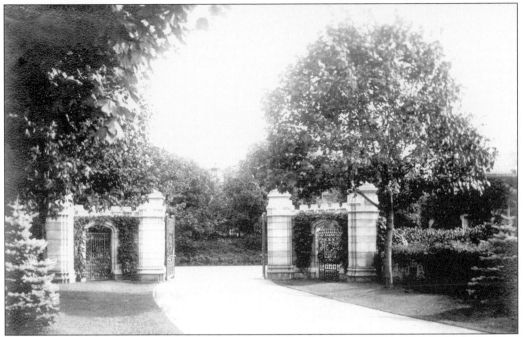

Seen are the entrance gates to Morton Plant's estate at Avery Point. (Carol W. Kimball.)

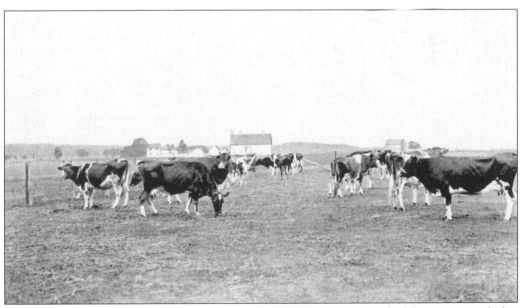

Morton Plant maintained a pedigreed herd of Guernsey cows at Branford Farms to supply his residence, Branford House, as well as the Griswold Hotel. These fields later became part of the Trumbull Airport property. (Jim Streeter.)

119

Tourist cabins sprang up along Route 1 in Poquonnock in the 1920s and 1930s to accommodate overnight travelers as automobiles became more and more popular. Gus Sonnenburg's Tourist Court on Route 1 is pictured here. (Jim Streeter.)

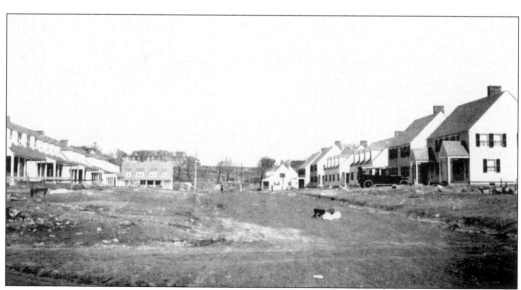

These houses on Morse Avenue in Groton are under construction during World War I. The housing was needed to accommodate workers at Groton Iron Works. (Jim Streeter.)

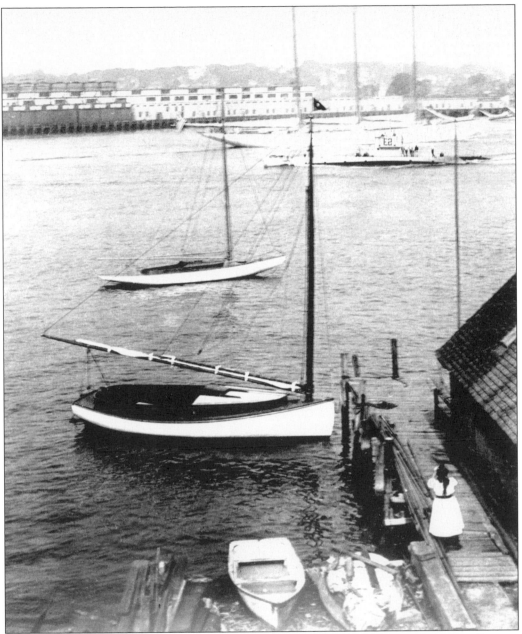

This photograph, taken from the rear of the Ferguson house on Thames Street in Groton, shows the catboat *Helena* at the dock. Sailing downriver is the submarine E-2 (formerly the *Sturgeon*), built in 1912. In the background is the 1916 State Pier in New London. (Ferguson family collection.)

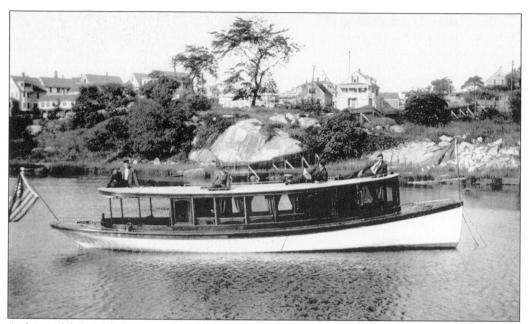

A beautiful launch travels down the Thames River with the Groton shoreline in the background. (Jim Streeter.)

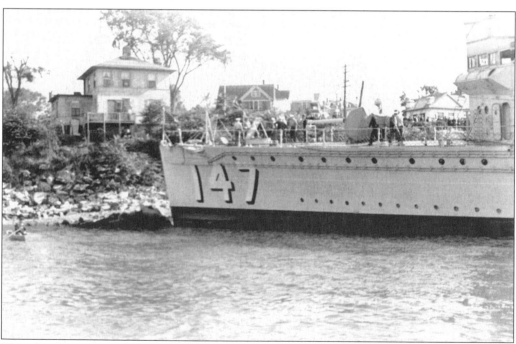

This destroyer, part of Pres. Franklin D. Roosevelt's neutrality patrol that operated out of New London Harbor, had a failure of its steering mechanism as it was getting under way. The photograph was taken in 1939 or 1940, prior to America's entry into World War II. (Arthur Greenleaf.)

The drum carried by John Gallup of Mystic in the Great Swamp Fight of King Philip's War in 1676 is on display at Monument House at Fort Griswold. It is said to be one of the oldest wooden drums in America. (Carol W. Kimball.)

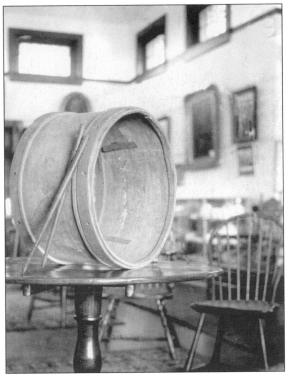

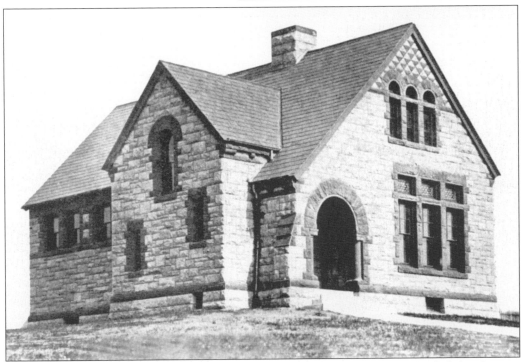

The Bill Memorial Library was the first public library in town. It was a gift of philanthropist Frederic Bill and was dedicated in 1890. It was later enlarged to include a museum. Bill and his two wives are buried on the grounds. (Jim Streeter.)

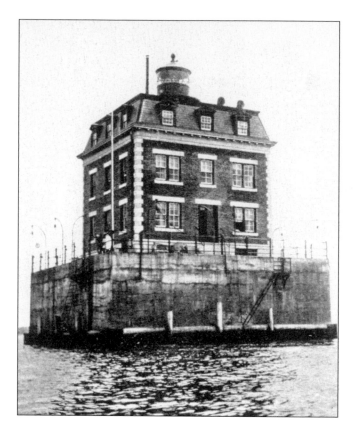

Commonly referred to as New London Ledge Light, the three-story brick lighthouse at the entrance to the Thames River is officially South West Ledge Light and is in the waters belonging to Groton. A latecomer among lighthouses, it began operating in 1910 and was automated on May 1, 1987. It is now under the care of the New London Ledge Light Foundation. (Jim Streeter.)

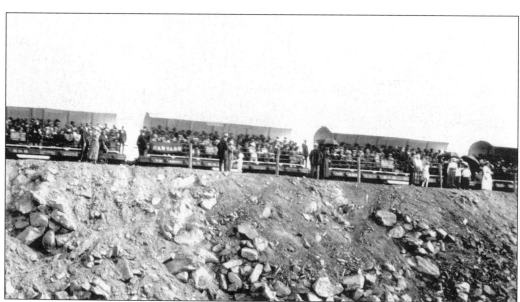

One of the best ways to view the annual Yale-Harvard rowing regatta each June was from train observation cars that ran on railroad tracks along both sides of the Thames River. The rolling cars allowed spectators to follow the race from the railroad bridge to Bartlett's Cove. (Jim Streeter.)

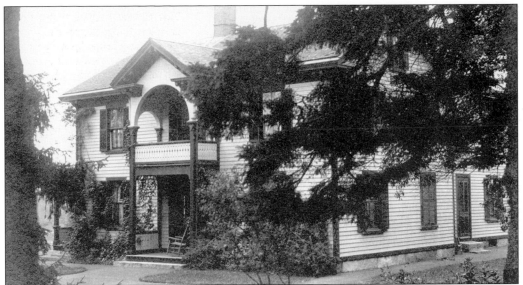

The Meech house in Groton was originally home to Susan Spicer Meech, who compiled the Spicer genealogy. The Spicer family was long known for its maritime captains. (Jim Streeter.)

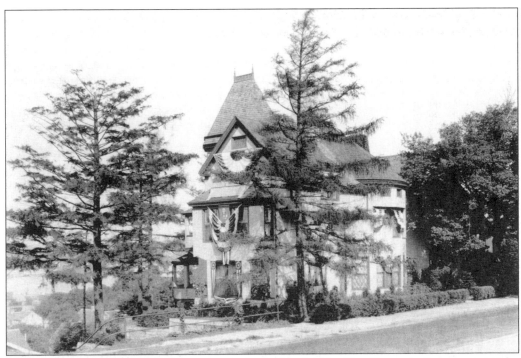

This house on Monument Street was once the home of Abby Day Slocomb, first regent of the Anna Warner Bailey chapter of the Daughters of the American Revolution and designer of Connecticut's state flag. Slocomb called her home Daisy Crest over Groton. It is now part of a condominium. (Sav Giordano.)

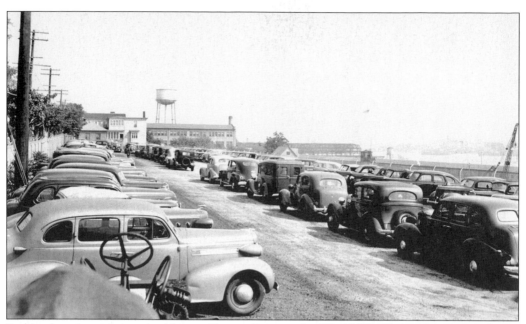

Parking has always been a problem at Electric Boat, as this World War II–era photograph shows. (Electric Boat Corporation.)

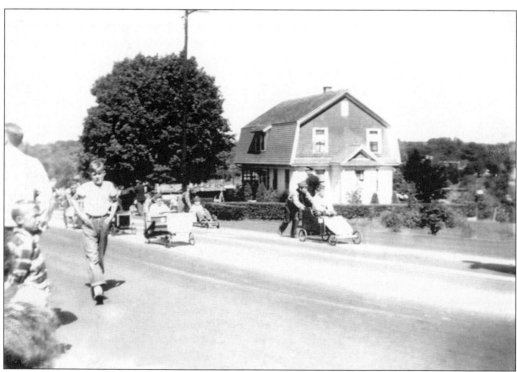

Boys take part in a Soap Box Derby in Groton in the early 1950s. (Wally Trolan.)

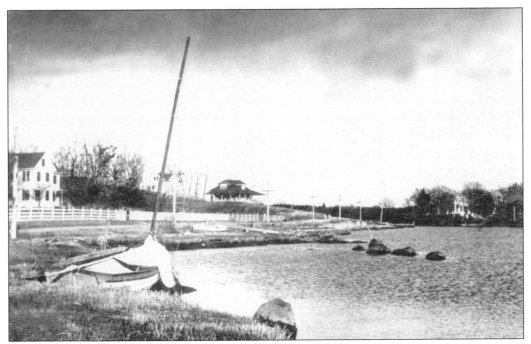

This view of River Road in Mystic is said to be the halfway point between Mystic village and Old Mystic. An early Mystic ferry run by Robert Burrows is believed to have crossed at this spot to the present Elm Grove Cemetery. The bungalow at the center of the photograph was built by Mary Leonard c. 1902. (Carol W. Kimball.)

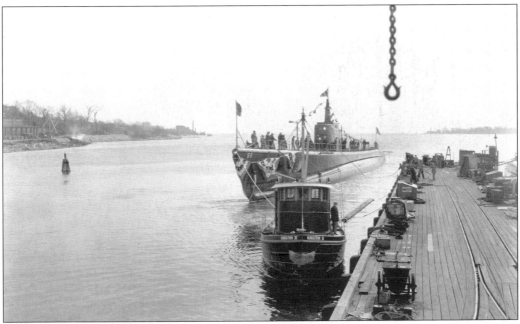

The submarine *Spearfish*, launched at Electric Boat on October 29, 1938, is towed back to dock. It was commissioned in 1939, and Lt. C. E. Tolman Jr. was its first commanding officer. (Jim Streeter.)

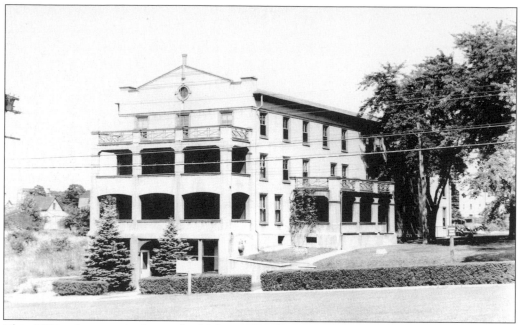

This 1920s photograph shows the Nelseco Hotel on Eastern Point Road where workers of Nelseco, now Electric Boat, stayed. The building was later used as the offices of the supervisor of shipbuilding for Electric Boat. The company still owns the building. (Jim Streeter.)

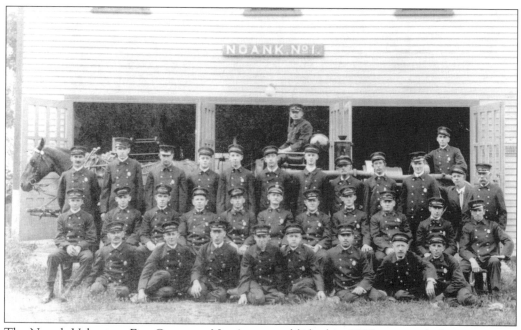

The Noank Volunteer Fire Company No. 1 was established in 1895 to provide fire protection to the small fishing and boatbuilding village. Members of the company pose in front of the original building that housed the fire company. The present building was constructed in the early 1950s. (Jim Streeter.)